THE
HOUND
OF THE
BASKERVILLES
A GRAPHIC NOVEL

SIR ARTHUR CONAN DOYLE
ILLUSTRATED BY DAVE SHEPHARD

San Diego, California

Canterbury Classics
An imprint of Printers Row Publishing Group
10350 Barnes Canyon Road, Suite 100, San Diego, CA 92121
www.canterburyclassicsbooks.com

Printers Row Publishing Group is a division of Readerlink Distribution
Services, LLC. Canterbury Classics is a registered trademark of
Readerlink Distribution Services, LLC.

All correspondence concerning the content of this book should be
addressed to Canterbury Classics, Editorial Department, at the
above address.

Publisher: Peter Norton
Associate Publisher: Ana Parker
Publishing/Editorial Team: April Farr, Kelly Larsen, Kathryn Chipinka,
Aaron Guzman
Editorial Team: JoAnn Padgett, Melinda Allman, Dan Mansfield
Script and introduction by Ned Hartley

Conceived, Designed and Produced by Quid Publishing,
an imprint of The Quarto Group
The Old Brewery, 6 Blundell Street,
London N7 9BH, United Kingdom
T (0) 20 7700 6700 F (0)20 7700 8066
www.QuartoKnows.com

Library of Congress Cataloging-in-Publication Data

Names: Shephard, David (Illustrator), illustrator, adapter.
Title: The hound of the Baskervilles / based on the story by Arthur Conan Doyle ; illustrated by
Dave Shephard.
Description: San Diego, California : Canterbury Classics, [2018] | Series: Dark tales
Identifiers: LCCN 2017038404 | ISBN 9781684121007 (softcover)
Subjects: LCSH: Doyle, Arthur Conan, 1859-1930. Hound of the Baskervilles--Adaptations. |
Holmes, Sherlock--Comic books, strips, etc. | Graphic novels.
Classification: LCC PN6727.S498 H68 2018 | DDC 741.5/973--dc23
LC record available at https://lccn.loc.gov/2017038404

Printed in China
21 20 19 18 17 1 2 3 4 5

CONTENTS

INTRODUCTION

The Hound of the Baskervilles was first published in *The Strand Magazine* in 1901—eight years after Sir Arthur Conan Doyle had killed off Sherlock Holmes by throwing him over the Reichenbach Falls. Conan Doyle had meant the 1893 short story "The Final Problem" to be Holmes's swan song, but he found it impossible to stay away from the world's greatest detective.

When asked about his inspirations for the novel, Conan Doyle once wrote in reply: "My story was really based on nothing save a remark of my friend Fletcher Robinson's that there was a legend about a dog on the moor connected with some old family." The family in question was that of Sir Richard Cabell, a seventeenth-century nobleman who legendarily sold his soul to the devil. Known in local myth as a monstrously evil man, he was said to have killed his first wife. He was then haunted by the ghost of her pet dog, which he also killed.

One of the reasons that *The Hound of the Baskervilles* has proved to be so enduring is that it's the perfect mix of whip-smart detective fiction, momentous locations, and hidden psychological horror. Not only is Conan Doyle telling a wonderful and surprising story—he's also creating the basis of the modern detective story as we know it. The desolate moor is a character in itself in *The Hound of the Baskervilles,* and that's something we've tried to maintain in this adaptation. Spooky and desolate during the day, dark and foreboding at night, it's the perfect location for a macabre ghost story.

When adapting this story, we looked at the narrative illustrations that accompanied the serialized story when it was first printed in *The Strand Magazine*. These illustrations were designed to have exciting visual hooks to draw the reader's eye, and that's something that we've tried to emulate and adapt. The art style needs to be simple enough to keep the narrative flowing, while at the same time drawing the reader into the story.

The art style in this adaptation is a mix between the stronger, more muscular artwork of modern horror comics like *The Walking Dead*, and the energy of contemporary Edwardian artwork like that seen in *Punch* magazine. The filled ink style gives a dark and foreboding feel to the narrative, while the clear linework shows us the emotions of the characters.

The power of *The Hound of the Baskervilles* comes from the incredible imagery that Conan Doyle conjures up—there's pure terror when Watson says "Never in the delirious dream of a disordered brain could anything more savage, more appalling, more hellish, be conceived than that dark form and savage face which broke upon us out of the wall of fog." These detailed descriptions make this a perfect tale to adapt as a graphic novel.

Sherlock Holmes will always be one of the most fascinating and popular characters in literary history, and each adaptation will take a different approach to how he should be represented. The Holmes here is influenced by the classic film and TV portrayals of Basil Rathbone and Jeremy Brett, and also the more recent iconic Holmes of Benedict Cumberbatch. We've tried to show him as a sharp, difficult, and tormented genius, someone who, despite his harsh exterior, is very much emotionally affected by the horrors of the moor…

DRAMATIS PERSONAE

The Hound of the Baskervilles

SIR CHARLES
BASKERVILLE

THE HOUND

DR. MORTIMER

SHERLOCK
HOLMES

DR. WATSON

SIR HENRY
BASKERVILLE

SELDEN

MR.
BARRYMORE

MRS.
BARRYMORE

MR.
STAPLETON

BERYL
STAPLETON

MR.
FRANKLAND

MRS. LYONS

INSPECTOR
LESTRADE

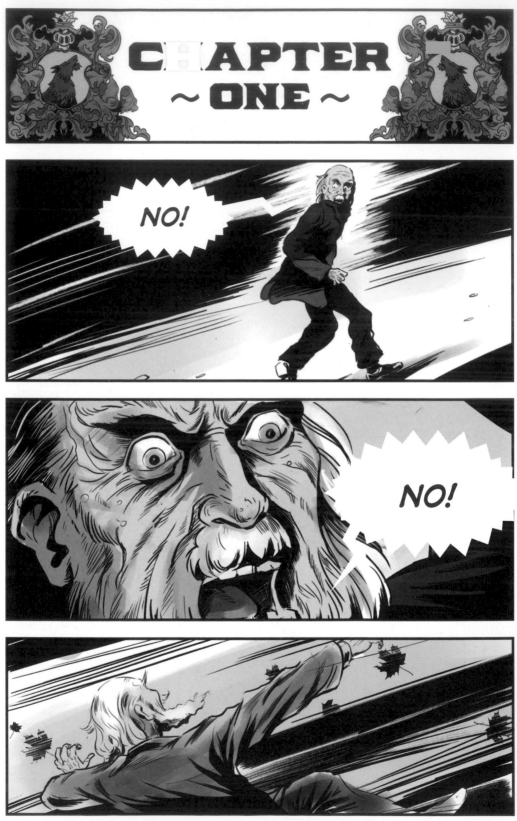

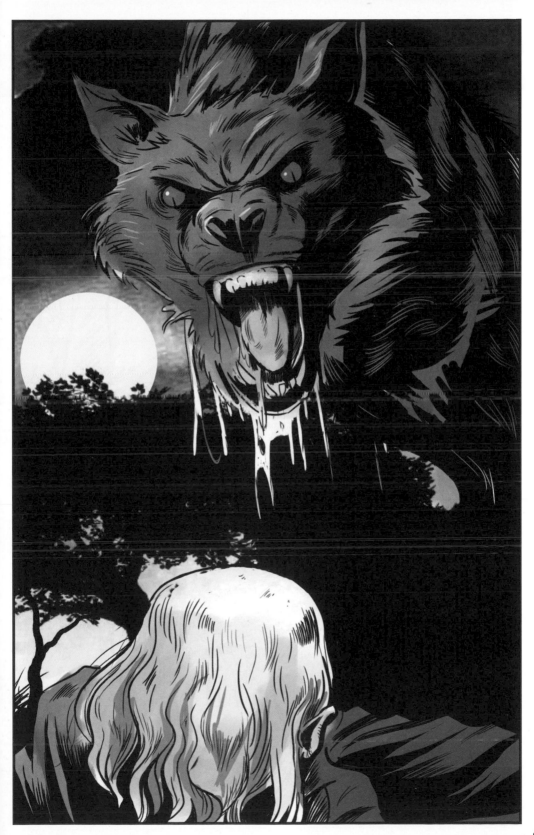

DR. MORTIMER, COME IN.

THIS MAY SEEM STRANGE...

I...

HM. I CAME TO YOU, MR. HOLMES, BECAUSE I AM CONFRONTED WITH AN...

WELL, AN... EXTRAORDINARY PROBLEM.

I AM NOT SURE HOW TO BEST BEGIN.

I HAVE IN MY POCKET A MANUSCRIPT.

IT WAS GIVEN TO ME BY SIR CHARLES BASKERVILLE, WHOSE SUDDEN AND TRAGIC DEATH SOME THREE MONTHS AGO CREATED SO MUCH EXCITEMENT IN DEVONSHIRE.

I WAS SIR CHARLES'S PERSONAL FRIEND AS WELL AS HIS MEDICAL ATTENDANT.

HE TOOK THIS DOCUMENT VERY SERIOUSLY.

I SEE.

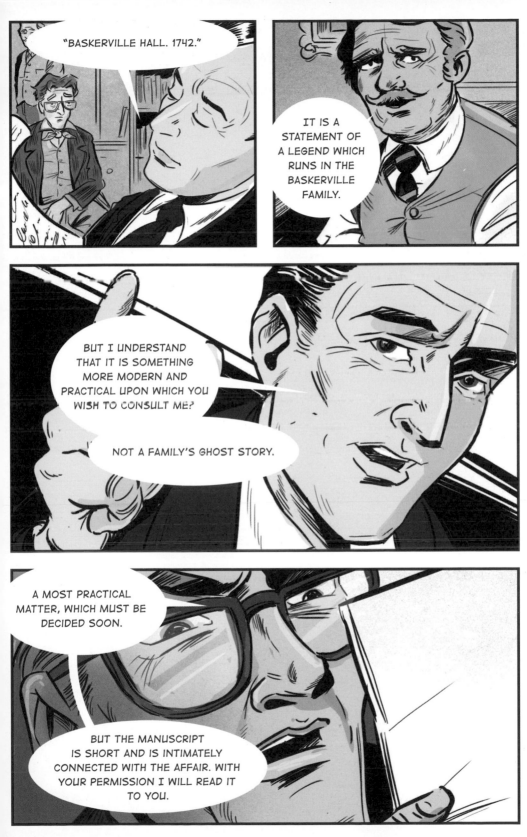

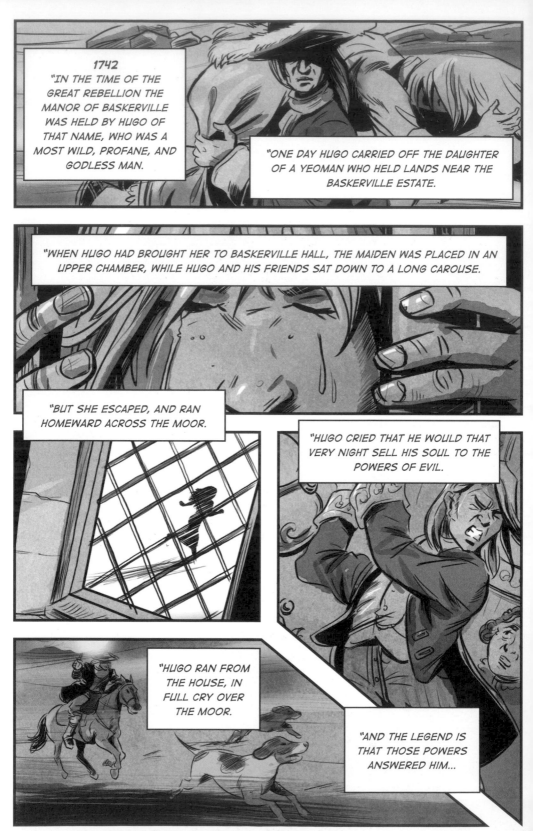

1742
"IN THE TIME OF THE GREAT REBELLION THE MANOR OF BASKERVILLE WAS HELD BY HUGO OF THAT NAME, WHO WAS A MOST WILD, PROFANE, AND GODLESS MAN.

"ONE DAY HUGO CARRIED OFF THE DAUGHTER OF A YEOMAN WHO HELD LANDS NEAR THE BASKERVILLE ESTATE.

"WHEN HUGO HAD BROUGHT HER TO BASKERVILLE HALL, THE MAIDEN WAS PLACED IN AN UPPER CHAMBER, WHILE HUGO AND HIS FRIENDS SAT DOWN TO A LONG CAROUSE.

"BUT SHE ESCAPED, AND RAN HOMEWARD ACROSS THE MOOR.

"HUGO CRIED THAT HE WOULD THAT VERY NIGHT SELL HIS SOUL TO THE POWERS OF EVIL.

"HUGO RAN FROM THE HOUSE, IN FULL CRY OVER THE MOOR.

"AND THE LEGEND IS THAT THOSE POWERS ANSWERED HIM...

"HUGO'S GUESTS FOLLOWED, AND FOUND HUGO LYING PRONE. STANDING OVER HUGO, AND PLUCKING AT HIS THROAT, THERE STOOD A FOUL THING, A GREAT, BLACK BEAST, SHAPED LIKE A HOUND, YET LARGER THAN ANY HOUND THAT EVER MORTAL EYE HAS RESTED UPON."

"MANY OF THE FAMILY HAVE BEEN UNHAPPY IN THEIR DEATHS, WHICH HAVE BEEN SUDDEN, BLOODY, AND MYSTERIOUS."

"SUCH IS THE TALE OF THE COMING OF THE HOUND, WHICH IS SAID TO HAVE PLAGUED THE FAMILY SO SORELY EVER SINCE."

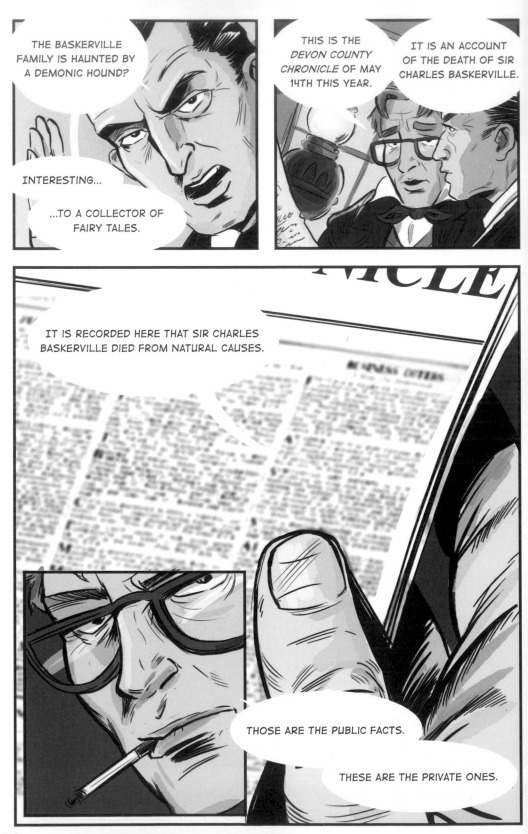

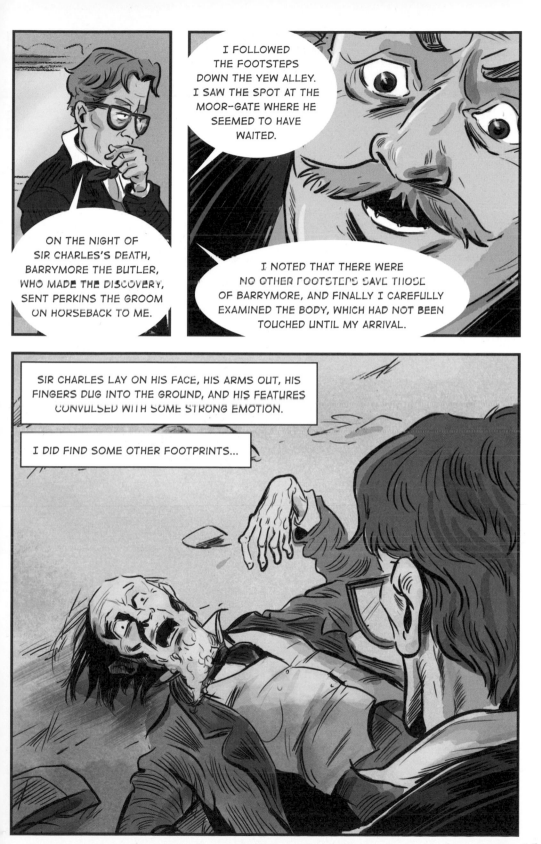

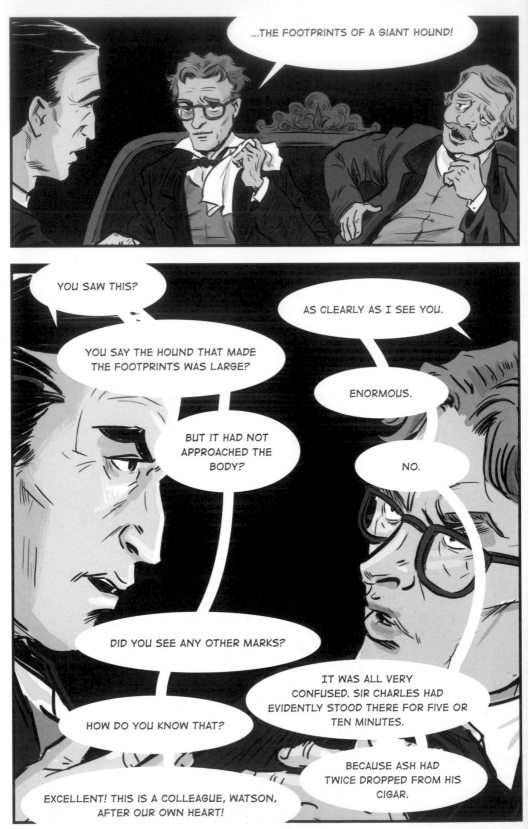

17

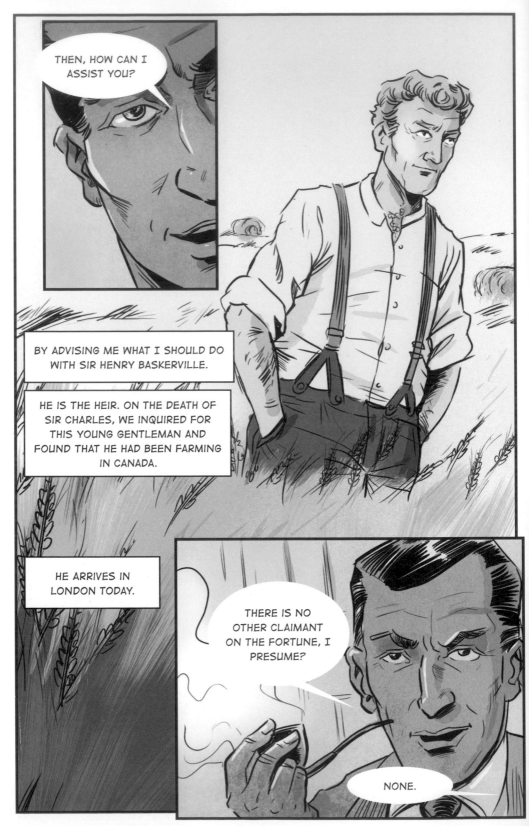

THE ONLY OTHER KINSMAN WHOM WE HAVE BEEN ABLE TO TRACE WAS RODGER BASKERVILLE, THE YOUNGEST OF THREE BROTHERS OF WHOM POOR SIR CHARLES WAS THE ELDER. THE SECOND BROTHER, WHO DIED YOUNG, IS THE FATHER OF THIS LAD HENRY.

THE THIRD, RODGER, WAS THE BLACK SHEEP OF THE FAMILY. HE FLED TO SOUTH AMERICA AND DIED IN 1876 OF YELLOW FEVER. HENRY IS THE LAST OF THE BASKERVILLES

SIR HENRY ARRIVES FROM CANADA TODAY. WHAT IS YOUR ADVICE, MR. HOLMES? WHAT SHOULD I DO WITH HIM?

IS THIS MAN'S LIFE IN DANGER? WHAT SHOULD I DO?

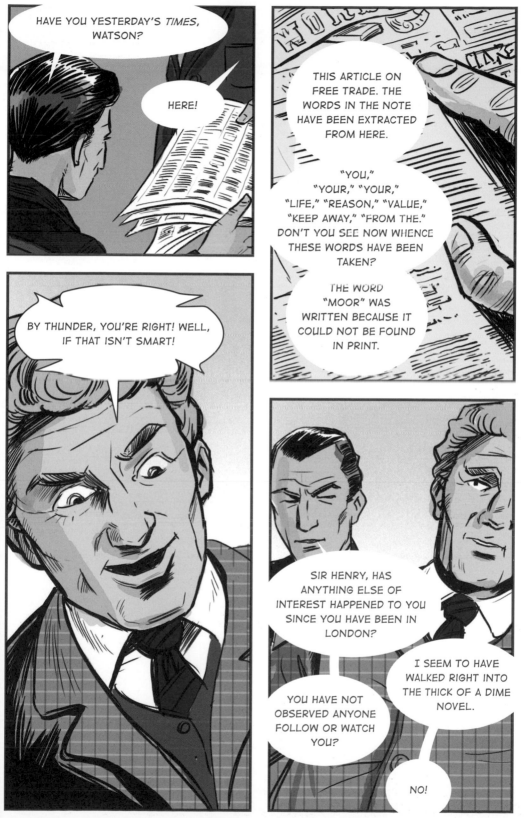

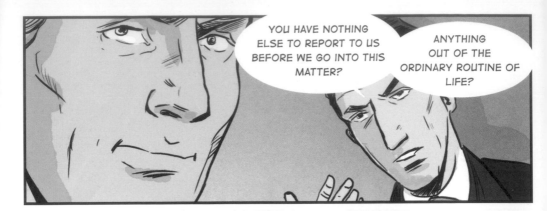

YOU HAVE NOTHING ELSE TO REPORT TO US BEFORE WE GO INTO THIS MATTER?

ANYTHING OUT OF THE ORDINARY ROUTINE OF LIFE?

WELL, THIS MAY BE FOOLISH, BUT...

I PUT BOTH MY BOOTS OUTSIDE MY DOOR LAST NIGHT, AND THERE WAS ONLY ONE IN THE MORNING. I COULD GET NO SENSE OUT OF THE CHAP WHO CLEANS THEM.

I ONLY BOUGHT THE PAIR LAST NIGHT AND I HAVE NEVER HAD THEM ON.

IT DOES SEEM TO BE A SINGULARLY USELESS THING TO STEAL.

HOWEVER, THIS WILL NOT SCARE ME.

THERE IS NO DEVIL IN HELL, MR. HOLMES, AND THERE IS NO MAN UPON EARTH WHO CAN PREVENT ME FROM GOING TO THE HOME OF MY OWN PEOPLE.

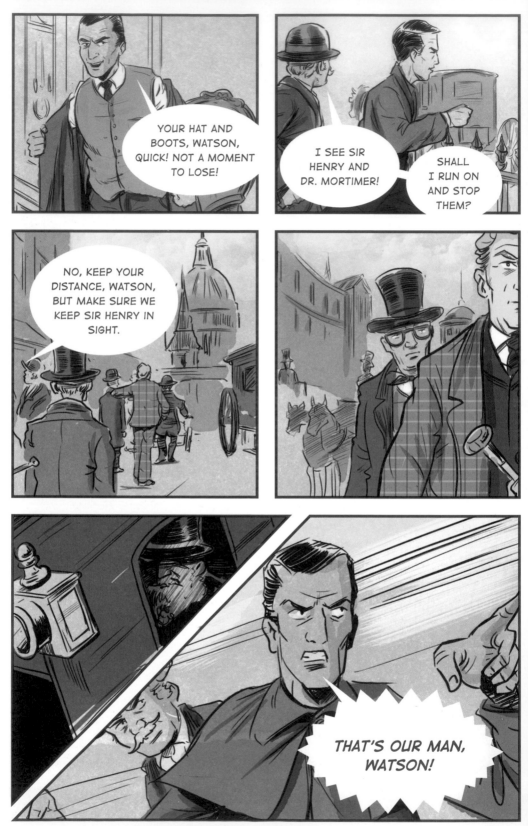

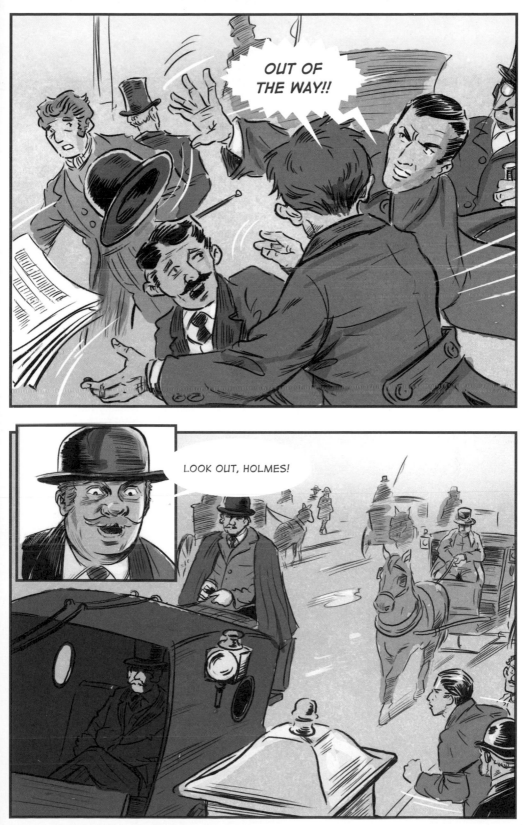

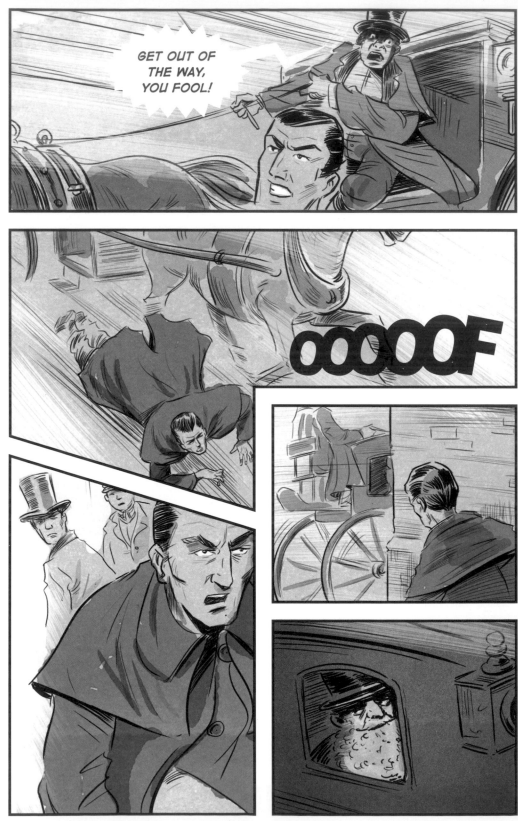

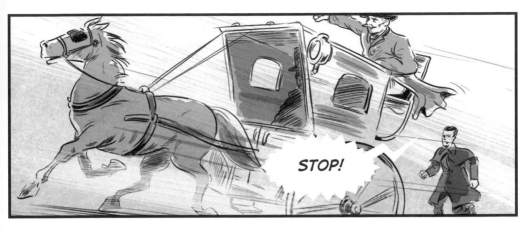

STOP!

WAS THERE EVER SUCH BAD LUCK AND SUCH BAD MANAGEMENT, TOO?

WHO WAS THE MAN?

I HAVE NO IDEA. IT WAS EVIDENT THAT SIR HENRY HAS BEEN CLOSELY SHADOWED BY SOMEONE SINCE HE HAS BEEN IN TOWN.

WE ARE DEALING WITH A CLEVER MAN, WATSON.

SO WILY THAT HE HAD NOT TRUSTED HIMSELF ON FOOT, BUT HAD AVAILED HIMSELF OF A CAB SO THAT HE COULD LOITER BEHIND OR DASH PAST SIR HENRY AND SO ESCAPE HIS NOTICE.

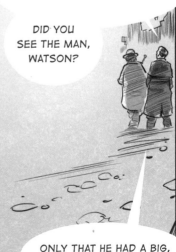

ON OBSERVING THE CAB, I SHOULD HAVE TURNED AND WALKED IN THE OTHER DIRECTION.

DID YOU SEE THE MAN, WATSON?

ONLY THAT HE HAD A BIG, BUSHY BEARD.

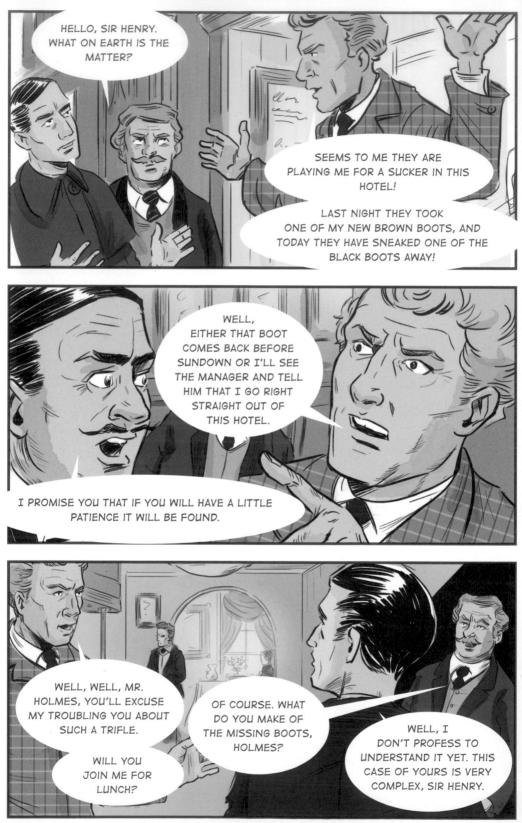

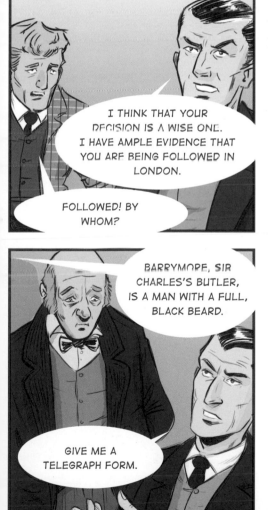

AND WHERE ARE YOUR INTENTIONS, SIR HENRY?

TO GO TO BASKERVILLE HALL. AT THE END OF THE WEEK.

I THINK THAT YOUR DECISION IS A WISE ONE. I HAVE AMPLE EVIDENCE THAT YOU ARE BEING FOLLOWED IN LONDON.

FOLLOWED! BY WHOM?

THAT, UNFORTUNATELY, IS WHAT I CANNOT TELL YOU. HAVE YOU AMONG YOUR NEIGHBORS OR ACQUAINTANCES ON DARTMOOR ANY MAN WITH A BLACK, FULL BEARD?

BARRYMORE, SIR CHARLES'S BUTLER, IS A MAN WITH A FULL, BLACK BEARD.

GIVE ME A TELEGRAPH FORM.

ADDRESS THIS TO THE NEAREST TELEGRAPH OFFICE. "IS ALL READY FOR SIR HENRY?" "TELEGRAM TO MR. BARRYMORE TO BE DELIVERED INTO HIS OWN HAND. IF ABSENT, PLEASE SEND A RETURN TELEGRAM TO SIR HENRY BASKERVILLE, NORTHUMBERLAND HOTEL."

THAT SHOULD DO IT.

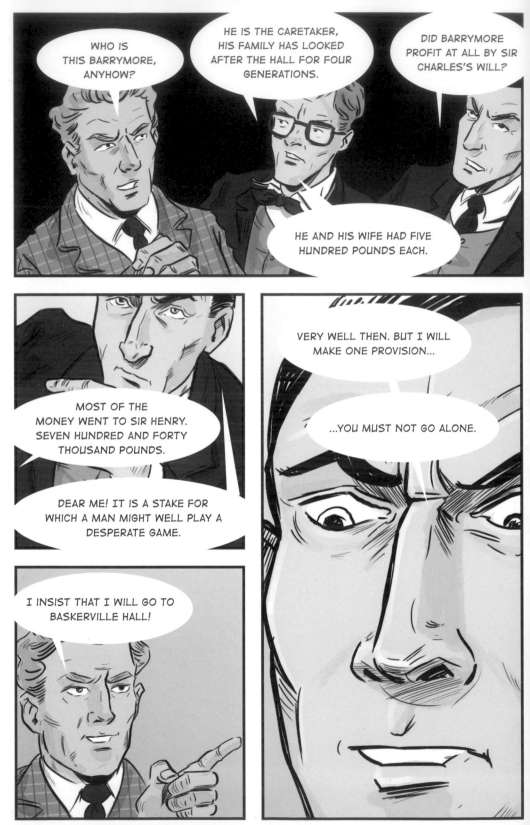

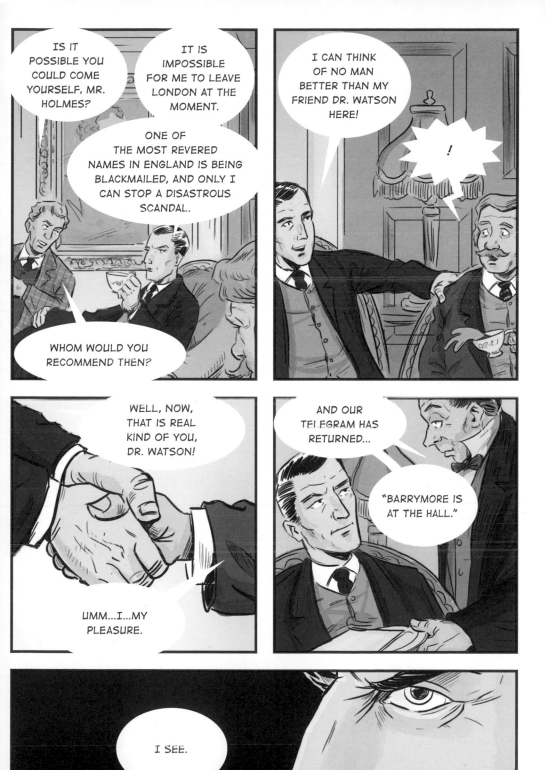

31

CHAPTER ~TWO~

REMEMBER, WATSON, SEND ME REPORTS OF THE FACTS AND LEAVE THE THEORIZING TO ME.

OUR SUSPECTS ARE THE PEOPLE WHO SURROUND SIR HENRY BASKERVILLE ON THE MOOR.

THE BARRYMORE COUPLE...

...OUR FRIEND DR. MORTIMER...

...THERE IS THIS NATURALIST, STAPLETON, AND HIS SISTER WHO IS SAID TO BE A YOUNG LADY OF ATTRACTIONS...

...THERE IS MR. FRANKLAND OF LAFTER HALL AND ONE OR TWO OTHER NEIGHBORS.

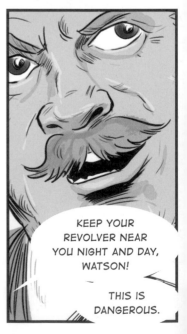

KEEP YOUR REVOLVER NEAR YOU NIGHT AND DAY, WATSON!

THIS IS DANGEROUS.

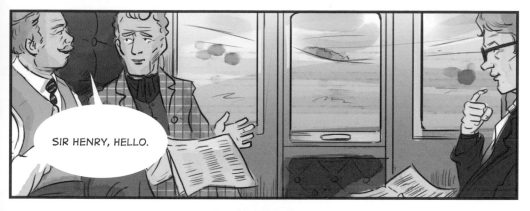

SIR HENRY, HELLO.

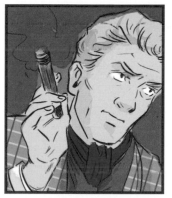

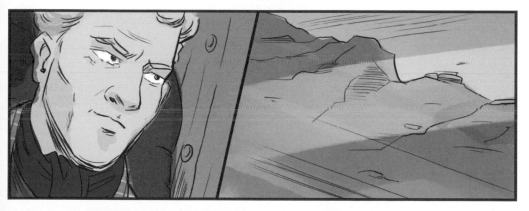

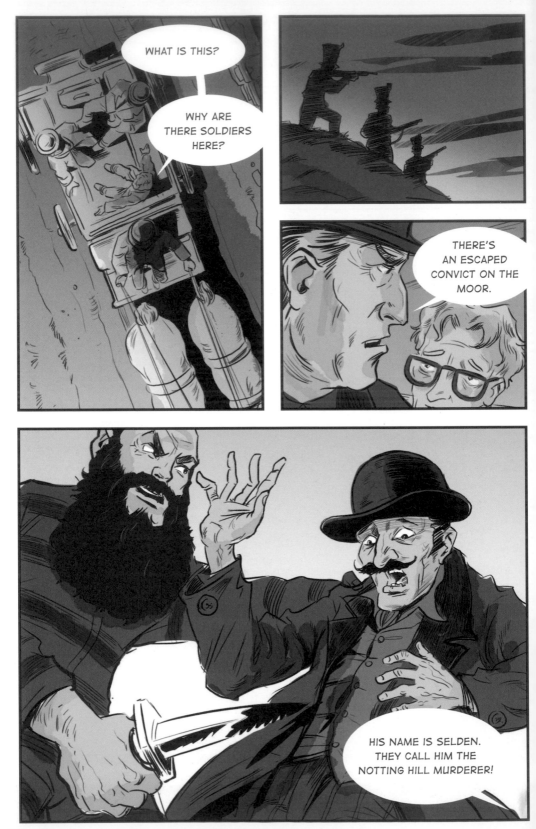

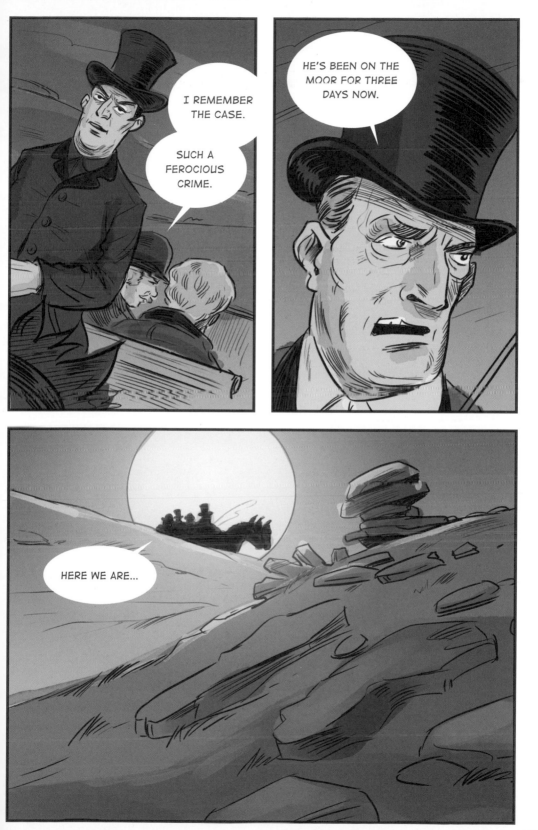

35

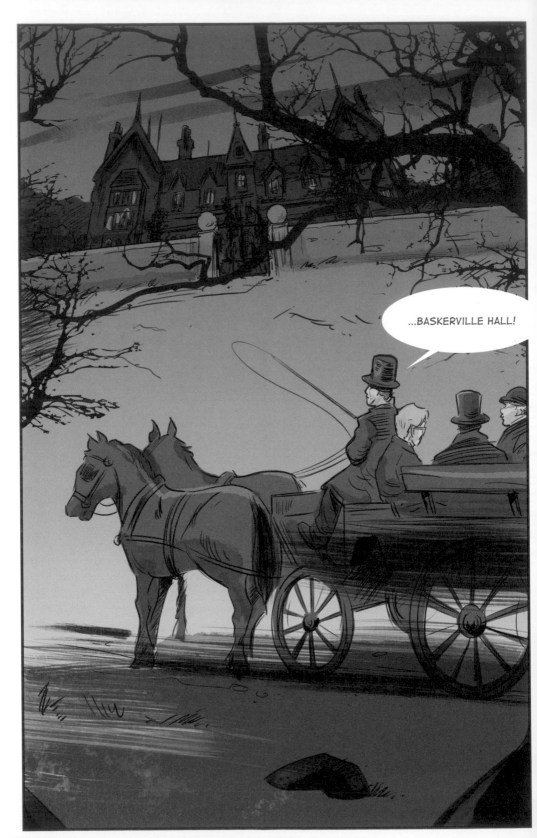

WAS IT HERE THAT SIR CHARLES...

NO, THE YEW ALLEY IS ON THE OTHER SIDE.

SO DARK. IT'S ENOUGH TO SCARE ANY MAN. I'LL HAVE A ROW OF ELECTRIC LAMPS UP HERE INSIDE OF SIX MONTHS.

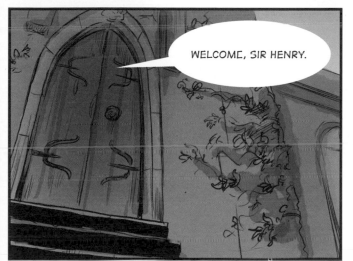

WELCOME, SIR HENRY.

WELCOME TO BASKERVILLE HALL. BARRYMORE, AT YOUR SERVICE

WELL, I MUST BE GOING. MY WIFE IS EXPECTING ME.

GOODBYE, SIR HENRY!

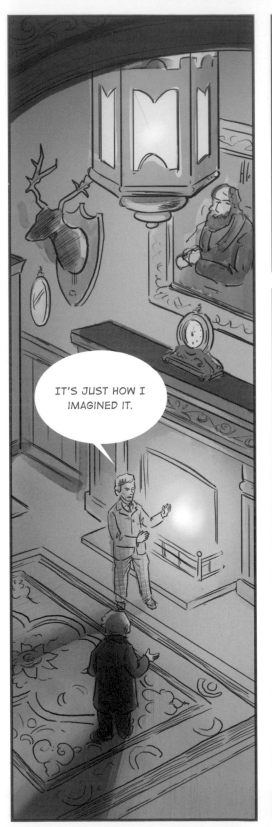

THIS WILL BE QUITE DIFFERENT UNDER A NEW STAFF. MY WIFE AND I WILL BE HAPPY TO STAY UNTIL IT IS CONVENIENT, SIR.

DO YOU AND YOUR WIFE WISH TO LEAVE?

IT'S JUST HOW I IMAGINED IT.

WE WERE BOTH VERY MUCH ATTACHED TO SIR CHARLES, AND HIS DEATH HAS MADE THESE SURROUNDINGS VERY PAINFUL TO US.

I UNDERSTAND.

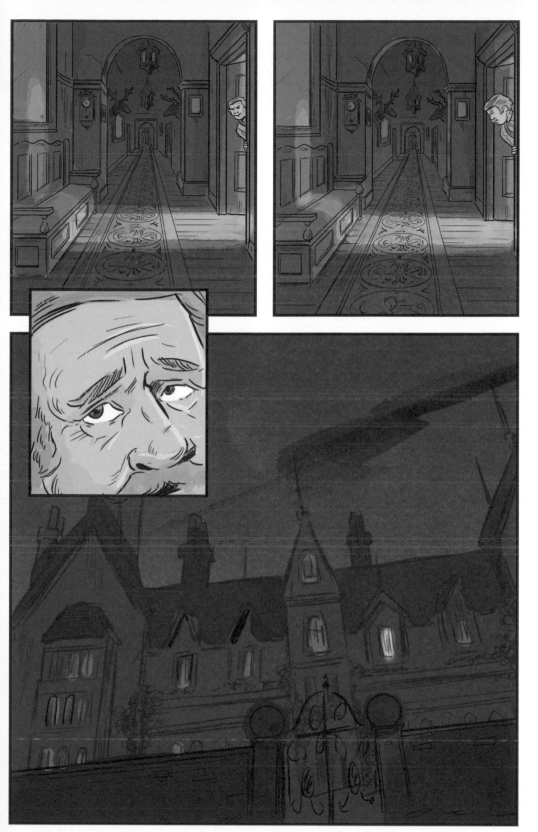

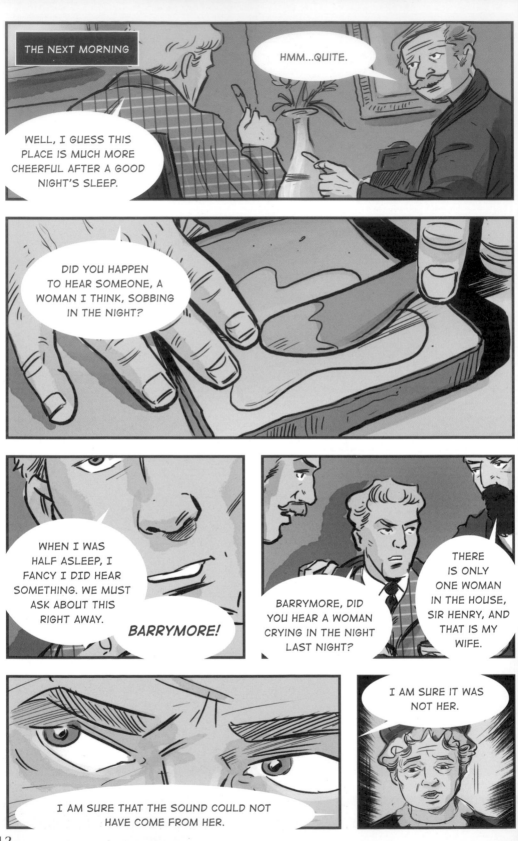

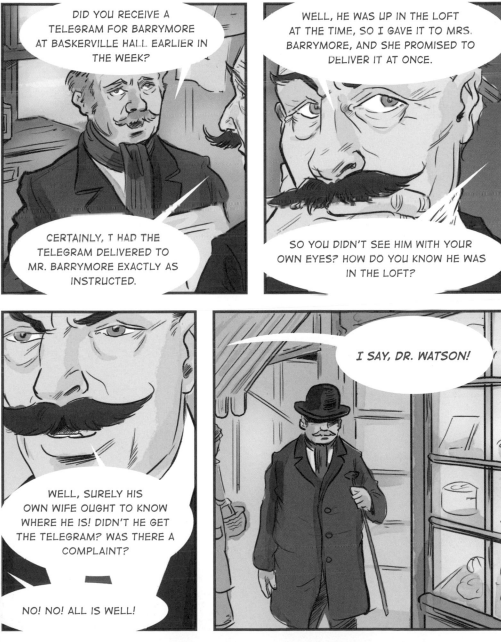

43

I AM STAPLETON.

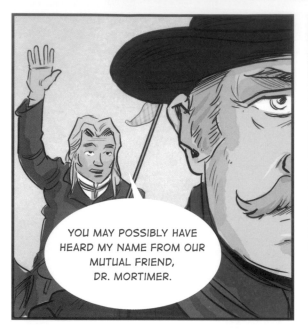

YOU MAY POSSIBLY HAVE HEARD MY NAME FROM OUR MUTUAL FRIEND, DR. MORTIMER.

YOUR NET AND BOX WOULD HAVE TOLD ME AS MUCH, FOR I KNEW THAT MR. STAPLETON WAS A NATURALIST.

BUT HOW DID YOU KNOW WHO I AM?

I WAS VISITING DR. MORTIMER AND HE POINTED YOU OUT TO ME FROM HIS WINDOW.

WILL YOU WALK WITH ME?

HOW IS SIR HENRY? OF COURSE YOU KNOW THE LEGEND OF THE FIEND DOG WHICH HAUNTS THE FAMILY...

I HAVE HEARD OF IT.

THE STORY TOOK A GREAT HOLD UPON THE IMAGINATION OF POOR SIR CHARLES. I HAVE NO DOUBT IT LED TO HIS TRAGIC END. I FANCY HE REALLY DID SEE SOMETHING, BUT HIS NERVES WERE SO DAMAGED THAT THE APPEARANCE OF ANY DOG WOULD HAVE HAD A FATAL EFFECT ON HIS WEAK HEART.

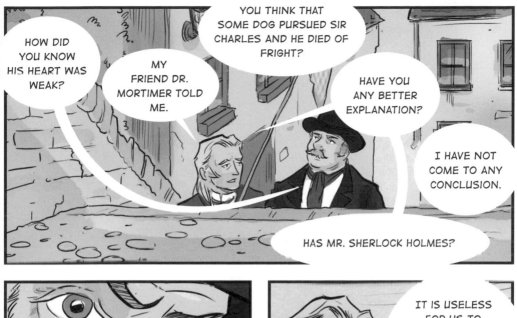

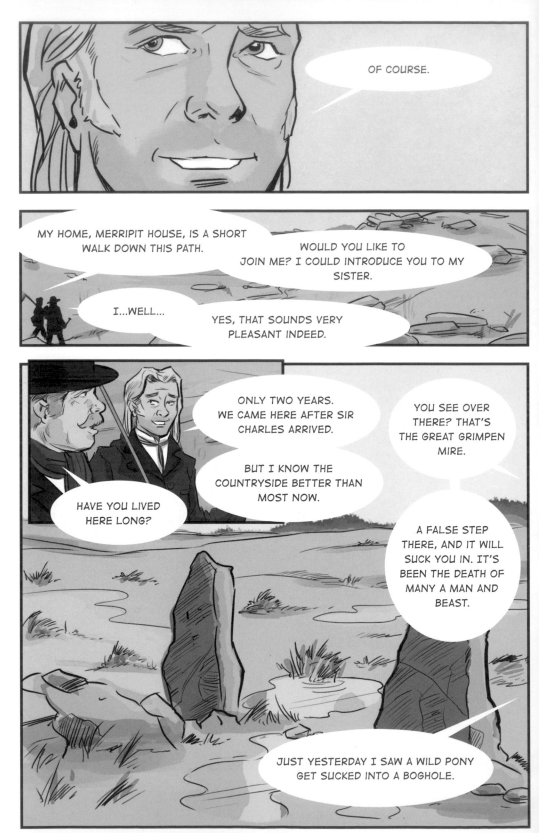

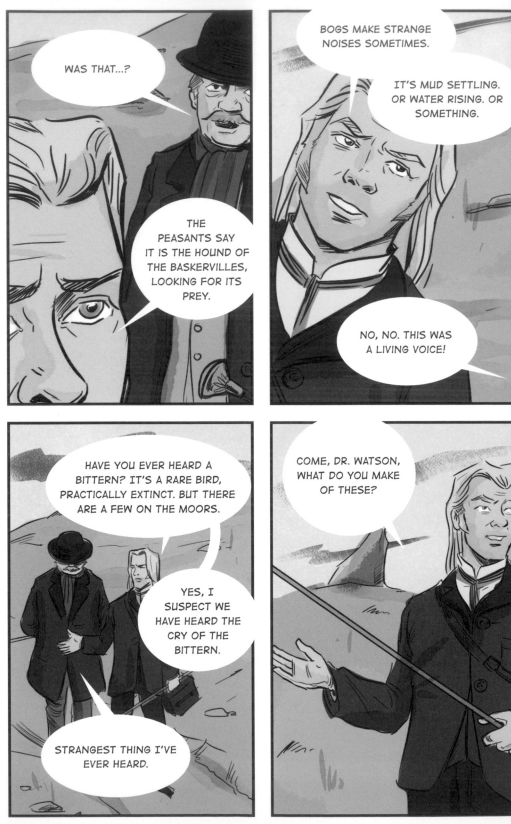

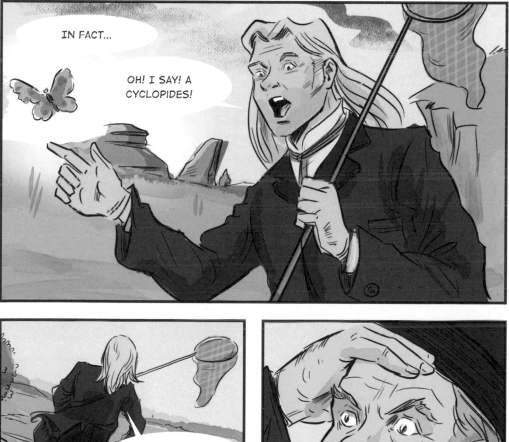

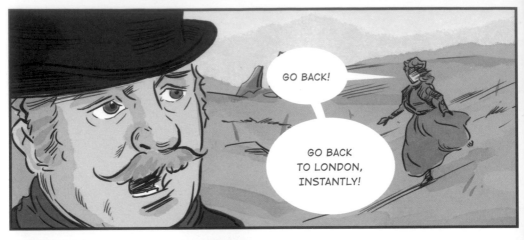

GO BACK!

GO BACK TO LONDON, INSTANTLY!

WH... WHAT?

I CANNOT EXPLAIN.

BUT FOR GOD'S SAKE, DO WHAT I ASK YOU!

CAN YOU NOT TELL WHEN A WARNING IS FOR YOUR OWN GOOD? GO...

HUSH, MY BROTHER IS COMING.

WOULD YOU MIND GETTING THAT ORCHID FOR ME?

WE HAVE MANY ORCHIDS ON THE MOOR THIS TIME OF YEAR.

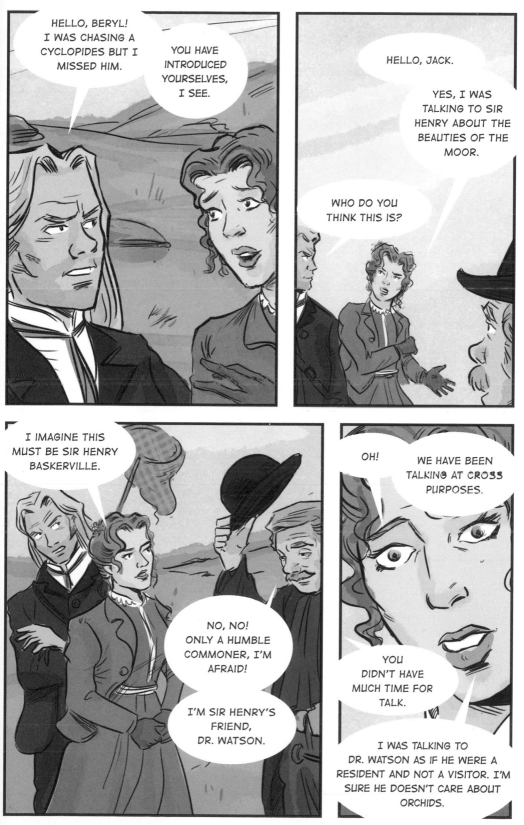

STRANGE SPOT FOR A HOUSE, I KNOW.

AND YET WE MANAGE TO KEEP OURSELVES HAPPY, DON'T WE, BERYL?

MMM. YES.

I HAD A SCHOOL IN THE NORTH OF ENGLAND. I ENJOYED MOLDING THE YOUNG MINDS, BUT SADLY, TRAGEDY STRUCK.

THERE WAS A SERIOUS EPIDEMIC AND THREE BOYS DIED.

I MISS MY SCHOOL. BUT I FOLLOWED MY TASTES IN BOTANY AND ZOOLOGY AND MOVED HERE. AND MY SISTER IS AS DEVOTED TO NATURE AS I AM.

OH, YES. VERY MUCH SO.

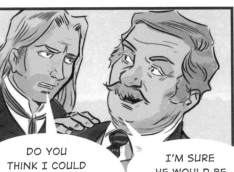

DO YOU THINK I COULD CALL AND MAKE THE ACQUAINTANCE OF SIR HENRY?

I'M SURE HE WOULD BE DELIGHTED.

EXCELLENT.

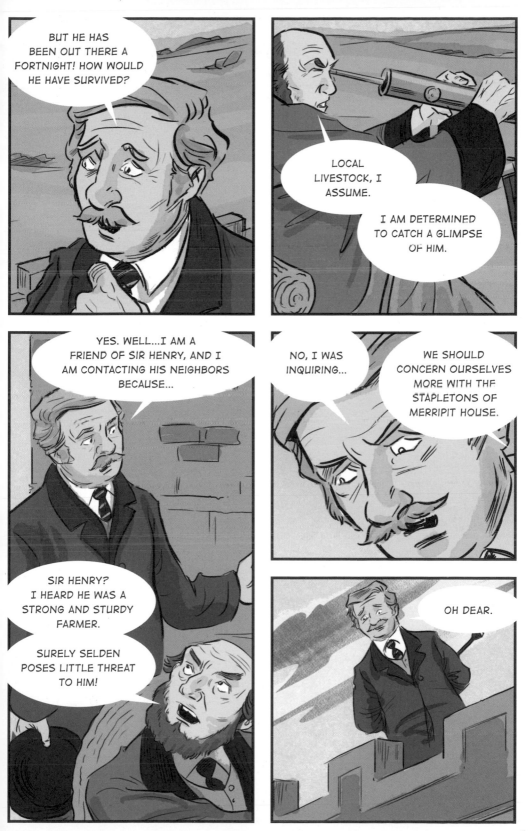

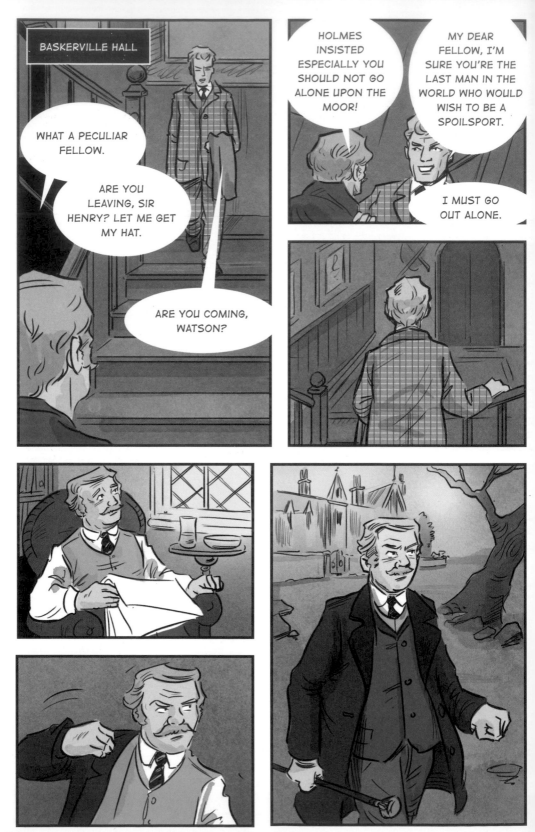

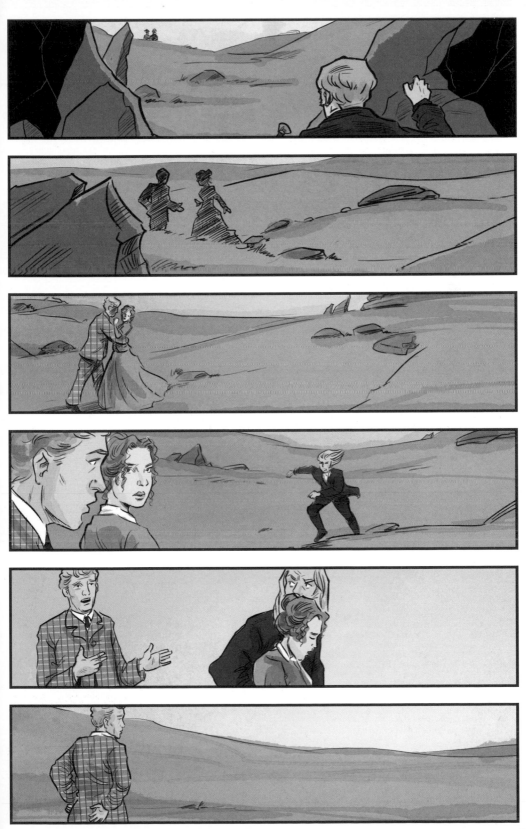

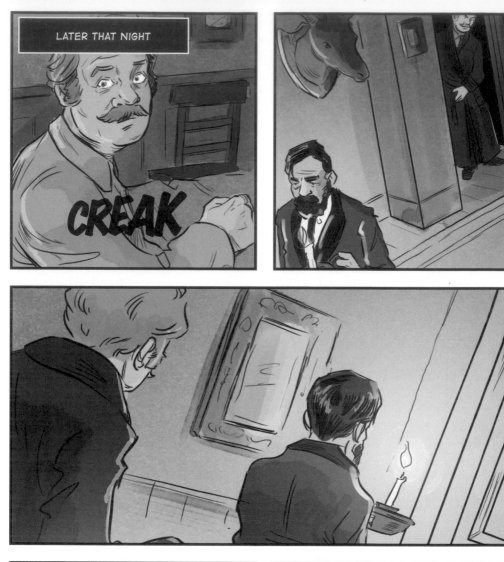

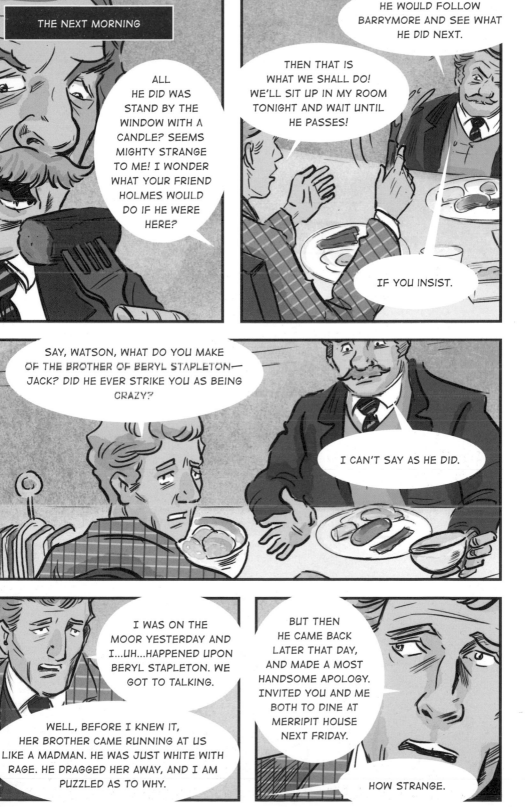

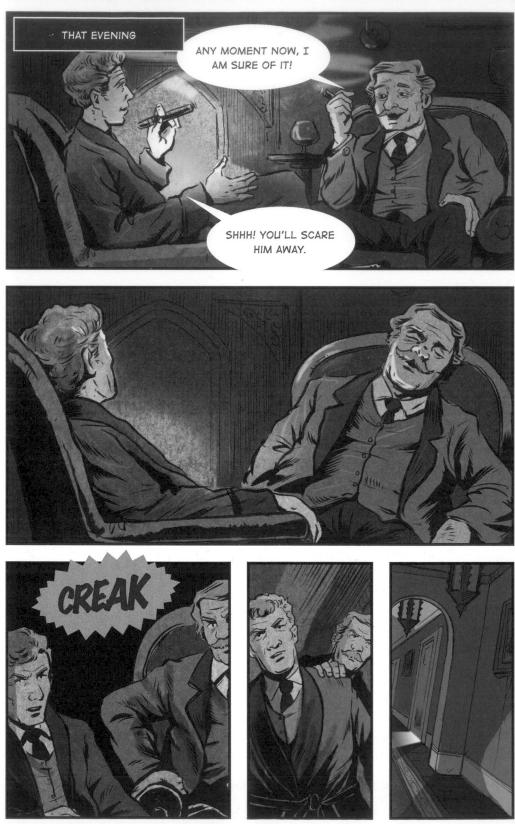

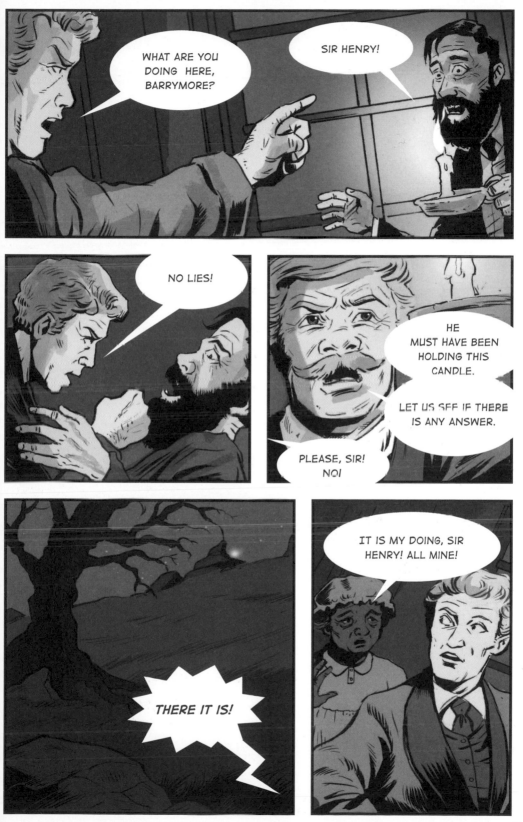

ELIZA! NO!

MY BROTHER IS ON THE MOOR. THE LIGHT IS A SIGNAL TO HIM THAT FOOD IS READY, AND HIS LIGHT SHOWS US WHERE TO BRING IT.

THEN YOUR BROTHER IS...

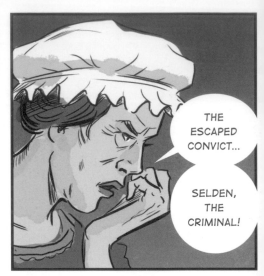

THE ESCAPED CONVICT...

SELDEN, THE CRIMINAL!

MY NAME WAS SELDEN AND HE IS MY YOUNGER BROTHER.

WE HUMORED HIM TOO MUCH AS A CHILD, I KNOW THAT NOW.

HE CAME TO THINK THE WORLD WAS MADE FOR HIS PLEASURE AND THAT HE COULD DO WHAT HE LIKED.

HE MET WICKED COMPANIONS, AND THE DEVIL ENTERED INTO HIM.

WHEN HE BROKE PRISON, HE KNEW THAT I WOULD NOT REFUSE TO HELP HIM.

WE TOOK HIM IN AND FED AND CARED FOR HIM.

WHEN YOU RETURNED, HE THOUGHT HE'D BE SAFER ON THE MOOR, SO HE HAS BEEN IN HIDING THERE.

I'M AFRAID WE EVEN GAVE HIM SOME OF YOUR OLD CLOTHES, SIR HENRY.

WELL, I CANNOT BLAME YOU FOR STANDING BY YOUR OWN WIFE.

GO TO YOUR ROOM, YOU TWO, AND WE SHALL TALK FURTHER IN THE MORNING.

HMM.

HOW FAR OUT DO YOU THINK IT IS?

NOT MORE THAN A MILE OR TWO OFF.

ARE YOU ARMED?

I HAVE A HUNTING CROP.

YES. WELL. I HAVE A REVOLVER.

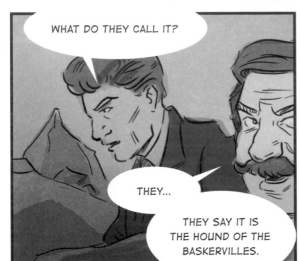

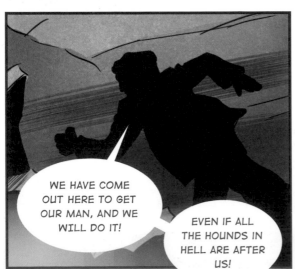

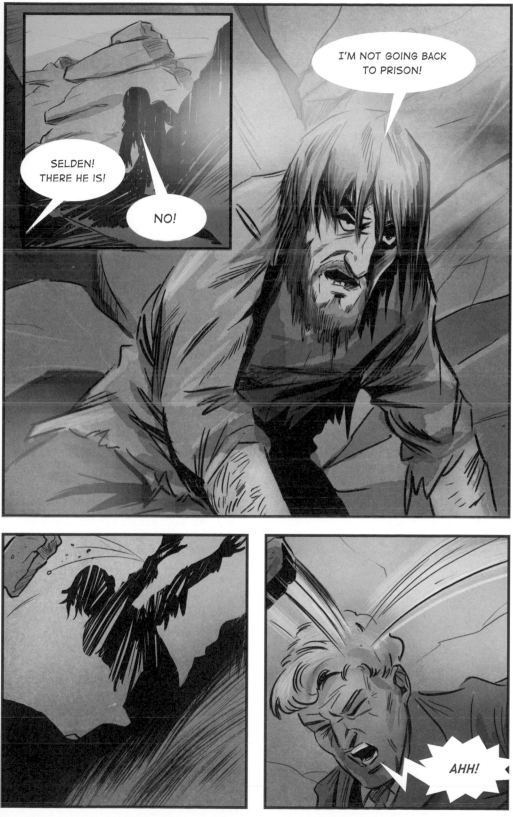

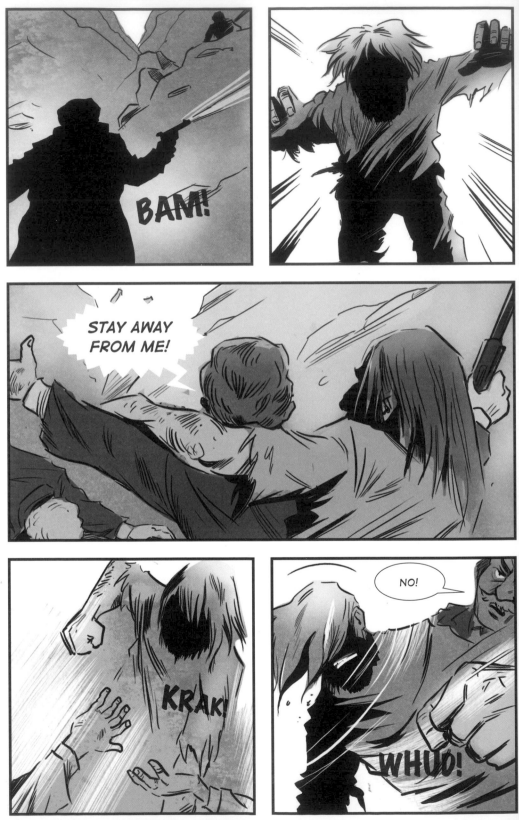

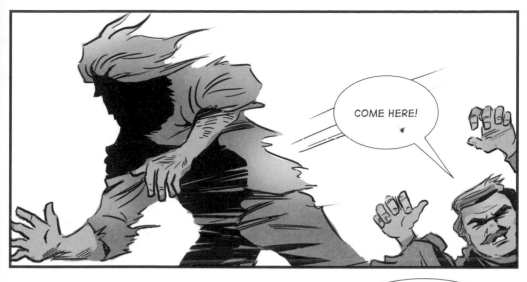

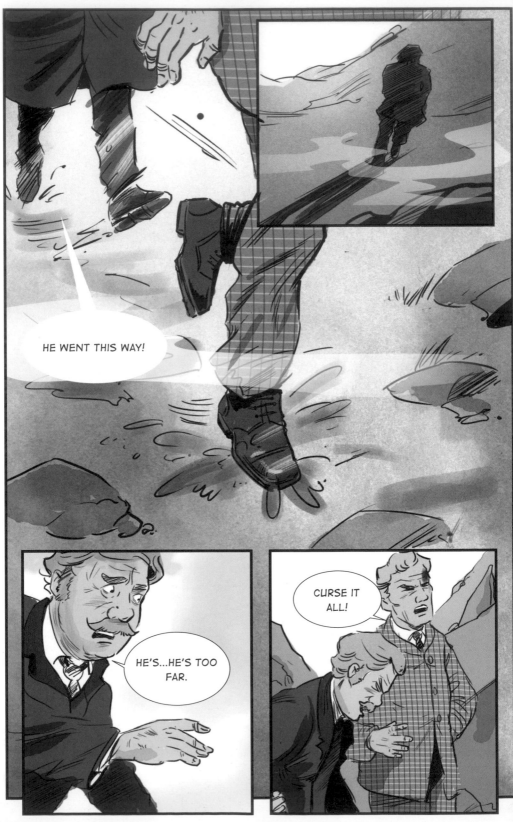

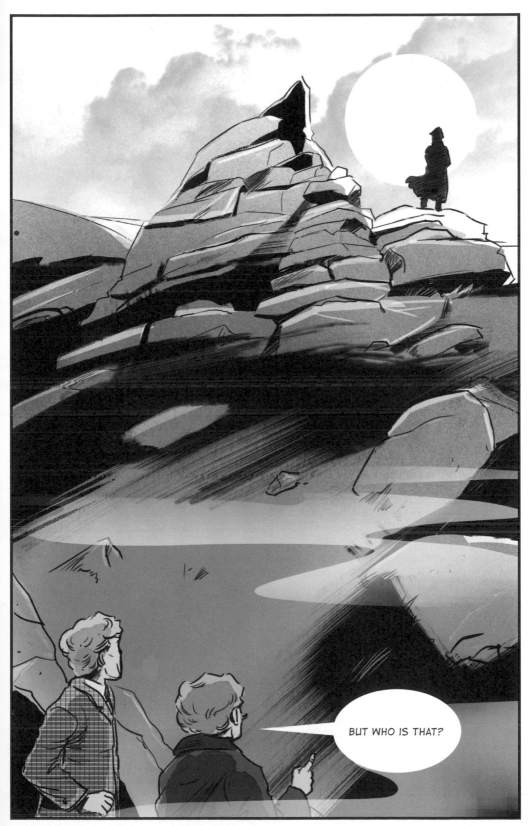

BUT WHO WAS THAT SECOND MAN ON THE MOOR?

A WARDER, NO DOUBT. ON THE TRAIL OF SELDEN.

PAY HIM NO MIND.

BARRYMORE! COME IN HERE, PLEASE!

SIR HENRY, I BEG YOUR PARDON, BUT I WAS VERY MUCH SURPRISED WHEN I LEARNED YOU HAD BEEN CHASING SELDEN. I DIDN'T THINK YOU WOULD HAVE TAKEN ADVANTAGE OF WHAT WE TOLD YOU.

THE MAN IS A PUBLIC DANGER. THERE'S NO SAFETY FOR ANYONE UNTIL HE'S UNDER LOCK AND KEY.

HE'LL NEVER TROUBLE ANYONE IN THIS COUNTRY AGAIN, SIR HENRY! IN A FEW DAYS HE WILL BE ON HIS WAY TO SOUTH AMERICA.

PLEASE, SAY NOTHING TO THE POLICE.

IF HE WERE OUT OF THE COUNTRY IT WOULD RELIEVE THE TAXPAYER OF A BURDEN.

AND YOU CAN PROMISE HE WILL NOT COMMIT A CRIME BEFORE HE GOES?

GOD BLESS YOU SIR, YES I CAN!

THANK YOU, SIR!

AS YOU HAVE BEEN SO KIND TO US, SIR, THERE WAS ONE THING. I KNOW SOMETHING...IT'S ABOUT POOR SIR CHARLES'S DEATH.

DO YOU KNOW HOW HE DIED?

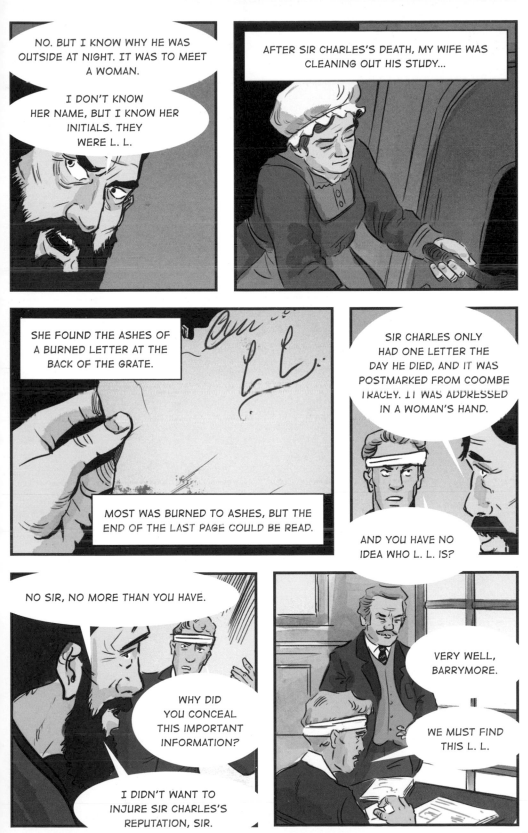

NO. BUT I KNOW WHY HE WAS OUTSIDE AT NIGHT. IT WAS TO MEET A WOMAN.

I DON'T KNOW HER NAME, BUT I KNOW HER INITIALS. THEY WERE L. L.

AFTER SIR CHARLES'S DEATH, MY WIFE WAS CLEANING OUT HIS STUDY...

SHE FOUND THE ASHES OF A BURNED LETTER AT THE BACK OF THE GRATE.

MOST WAS BURNED TO ASHES, BUT THE END OF THE LAST PAGE COULD BE READ.

SIR CHARLES ONLY HAD ONE LETTER THE DAY HE DIED, AND IT WAS POSTMARKED FROM COOMBE TRACEY. IT WAS ADDRESSED IN A WOMAN'S HAND.

AND YOU HAVE NO IDEA WHO L. L. IS?

NO SIR, NO MORE THAN YOU HAVE.

WHY DID YOU CONCEAL THIS IMPORTANT INFORMATION?

I DIDN'T WANT TO INJURE SIR CHARLES'S REPUTATION, SIR.

VERY WELL, BARRYMORE.

WE MUST FIND THIS L. L.

CHAPTER ~ FOUR ~

DR. WATSON!

LET ME DRIVE YOU HOME! I INSIST!

THANK YOU, MORTIMER. BY THE WAY, I SUPPOSE YOU KNOW EVERYONE IN DRIVING DISTANCE?

CAN YOU THINK OF ANY WOMAN WHOSE INITIALS ARE L. L.?

WELL, THERE IS LAURA LYONS, BUT SHE LIVES IN COOMBE TRACEY.

SHE'S FRANKLAND'S DAUGHTER.

WHAT? FRANKLAND THE OLD CRANK?

EXACTLY. SHE MARRIED AN ARTIST NAMED LYONS, BUT HE DESERTED HER.

HER FATHER REFUSED TO HAVE ANYTHING TO DO WITH HER BECAUSE SHE MARRIED WITHOUT HIS CONSENT. I DARE SAY SHE STILL GETS A PITTANCE FROM HIM.

WOULD YOU TAKE ME TO COOMBE TRACEY?

YES?

MRS. LYONS? MY NAME IS DR. WATSON.

I HAVE COME TO SEE YOU REGARDING THE LATE SIR CHARLES BASKERVILLE.

OH!

IT IS WELL KNOWN I OWE A GREAT DEAL TO HIS KINDNESS.

WHY ARE YOU ASKING ME ABOUT HIM?

I...AH...I HAVE COME HERE...I HAVE COME TO AVOID A PUBLIC SCANDAL. I AM HOPING NOT TO SULLY SIR CHARLES'S NAME.

VERY WELL. THERE WERE SEVERAL GENTLEMEN WHO KNEW MY SAD STORY AND UNITED TO HELP ME.

ONE WAS MR. STAPLETON, AND IT WAS THROUGH HIM THAT SIR CHARLES LEARNED OF MY AFFAIRS.

I ONLY MET SIR CHARLES ONCE OR TWICE. HE PREFERRED TO DO GOOD BY STEALTH.

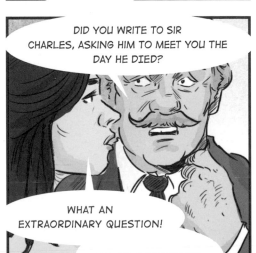

DID YOU WRITE TO SIR CHARLES, ASKING HIM TO MEET YOU THE DAY HE DIED?

WHAT AN EXTRAORDINARY QUESTION!

NO, OF COURSE NOT.

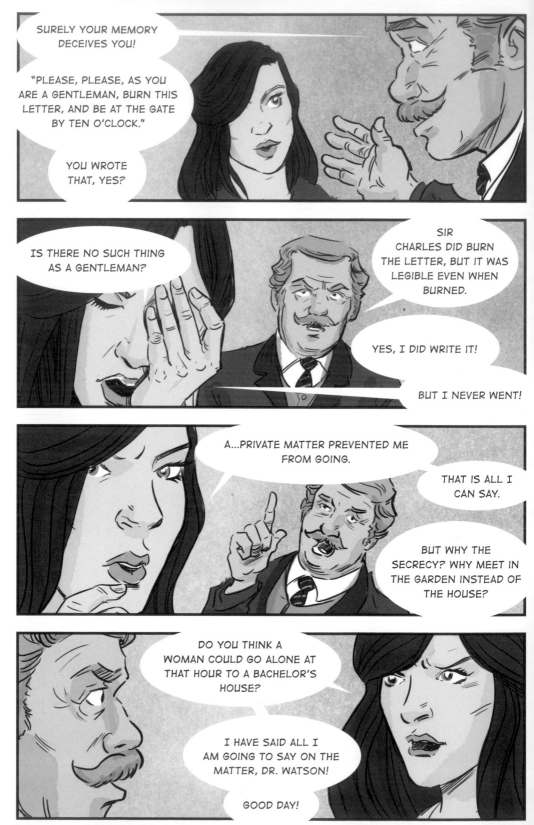

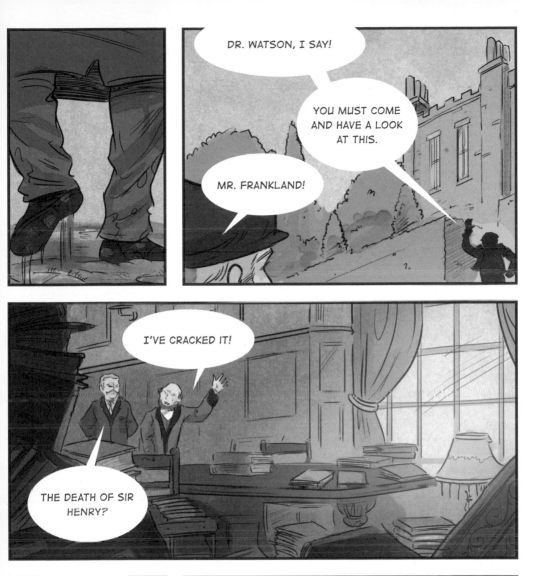

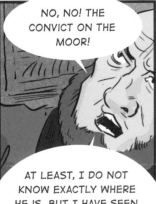

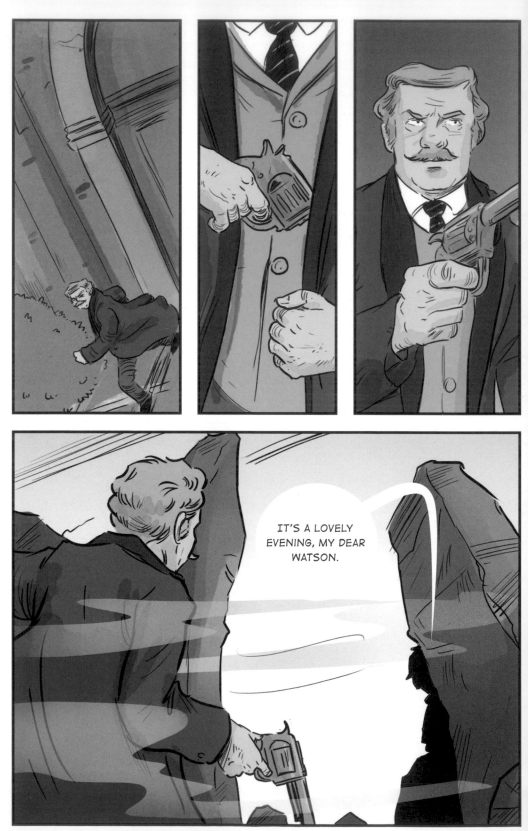

IT'S A LOVELY EVENING, MY DEAR WATSON.

WHY DID YOU NOT CONFIDE IN ME?

IF YOU'D HAVE KNOWN I WAS HERE, YOU WOULD HAVE TRIED TO HELP ME, AND LED TO MY DISCOVERY.

MY DEAR FELLOW, YOU WILL FORGIVE ME IF I SEEM TO HAVE PLAYED A TRICK ON YOU.

THIS CASE IS SO DANGEROUS I HAD TO REMAIN AN UNKNOWN FACTOR, TO KEEP SIR HENRY SAFE.

NOW.

YOU VISITED LAURA LYONS. YOU ARE AWARE THAT AN INTIMACY EXISTS BETWEEN HER AND MR. STAPLETON.

DESPITE HIS WIFE...

HIS WIFE?!

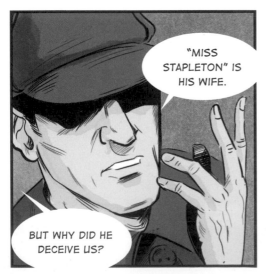

"MISS STAPLETON" IS HIS WIFE.

BUT WHY DID HE DECEIVE US?

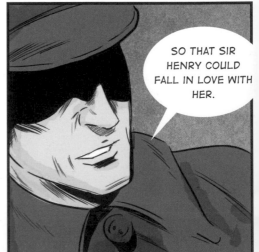

SO THAT SIR HENRY COULD FALL IN LOVE WITH HER.

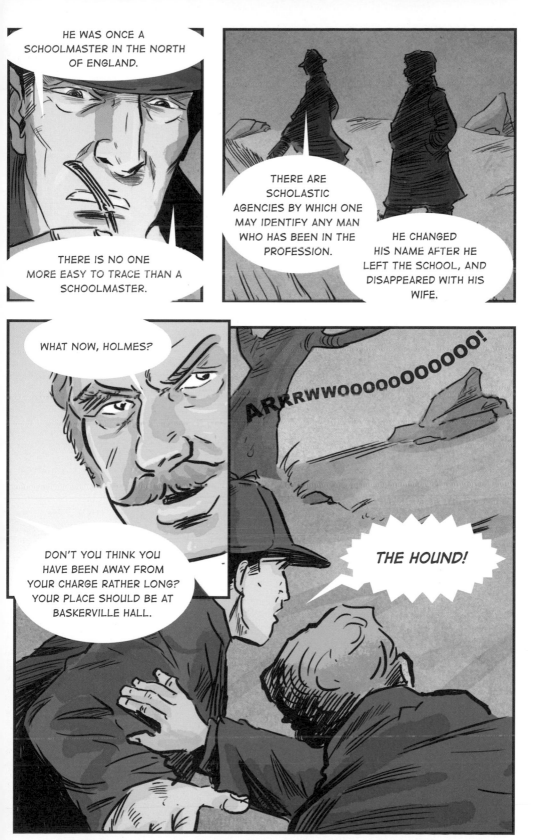

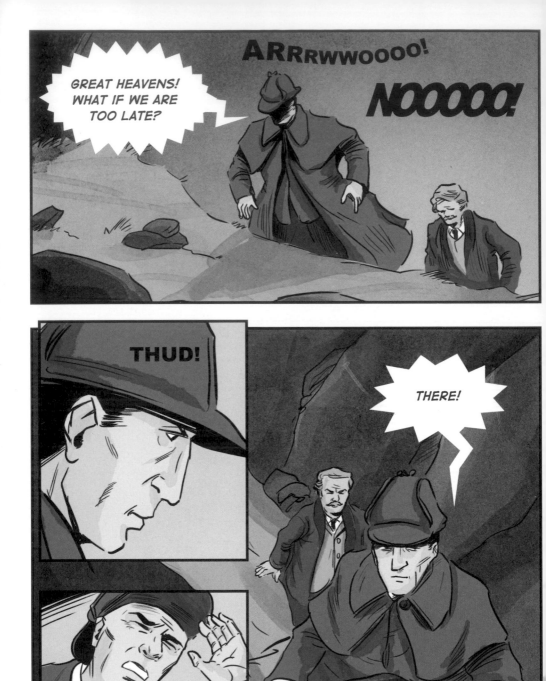

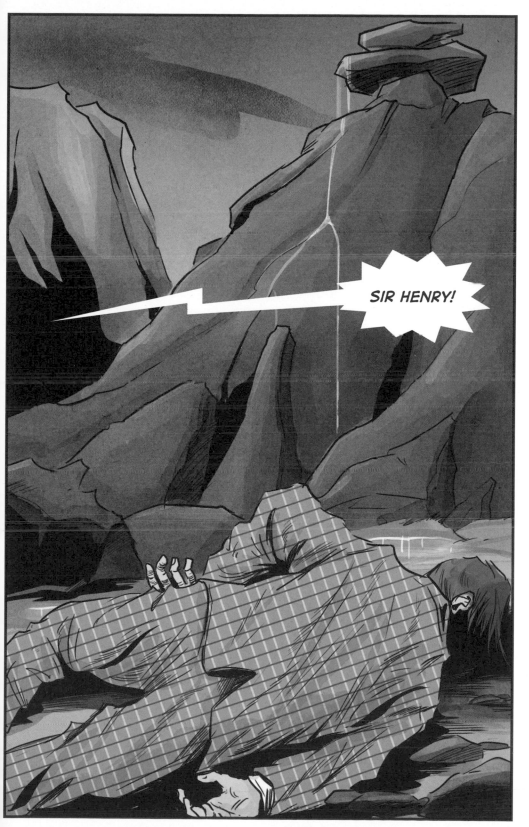

83

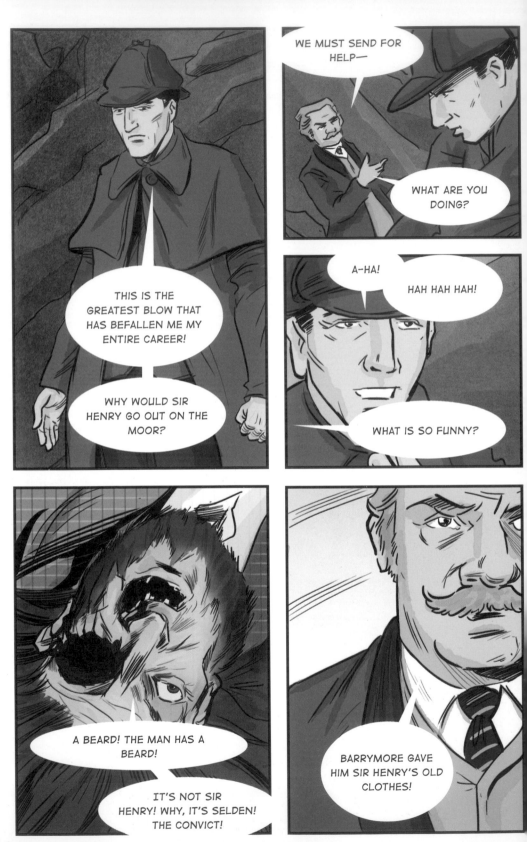

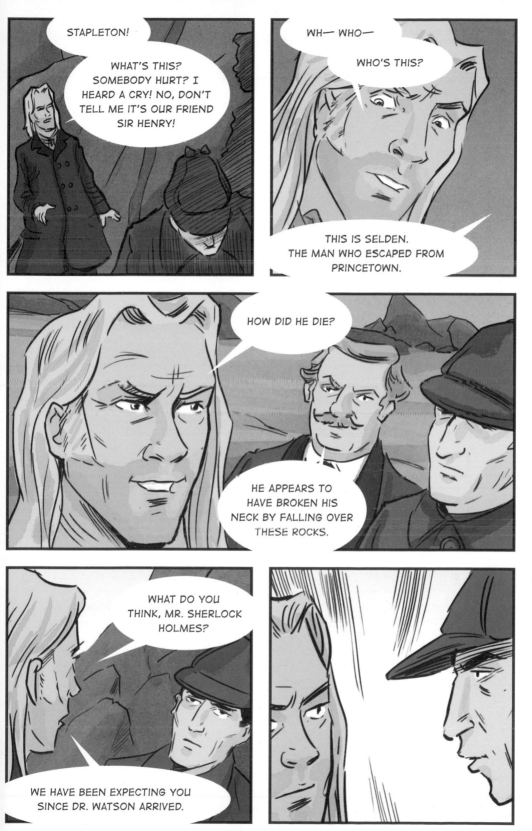

OH.

WELL, WE SHALL BE—

MY FRIEND'S EXPLANATION SEEMS CORRECT.

EITHER WAY, I WILL RETURN TO LONDON TOMORROW. THIS HAS NOT BEEN A SATISFACTORY CASE.

NOT SATISFACTORY AT ALL.

GOODBYE.

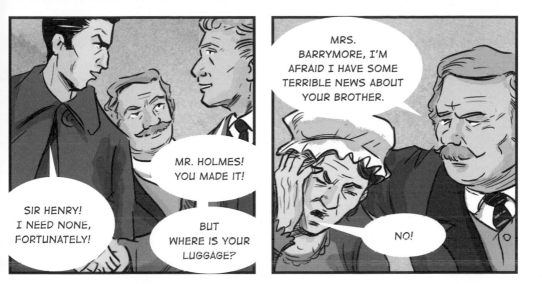

MRS. BARRYMORE, I'M AFRAID I HAVE SOME TERRIBLE NEWS ABOUT YOUR BROTHER.

MR. HOLMES! YOU MADE IT!

SIR HENRY! I NEED NONE, FORTUNATELY!

BUT WHERE IS YOUR LUGGAGE?

NO!

I'VE BEEN MOPING AROUND ALL DAY BECAUSE I PROMISED NOT TO LEAVE THE HOUSE ALONE. I MIGHT'VE HAD A MORE LIVELY EVENING, FOR I HAD A MESSAGE FROM STAPLETON ASKING ME OVER THERE.

I HAVE NO DOUBT ABOUT THAT.

YOU KNOW THAT WE WERE MOURNING YOUR DEATH? SELDEN WAS WEARING YOUR CLOTHES.

BARRYMORE!

QUITE.

IF YOU WISH TO RESOLVE THIS MATTER, YOU MUST DO EXACTLY AS I SAY.

YOU MUST DO IT BLINDLY AND WITHOUT REASON.

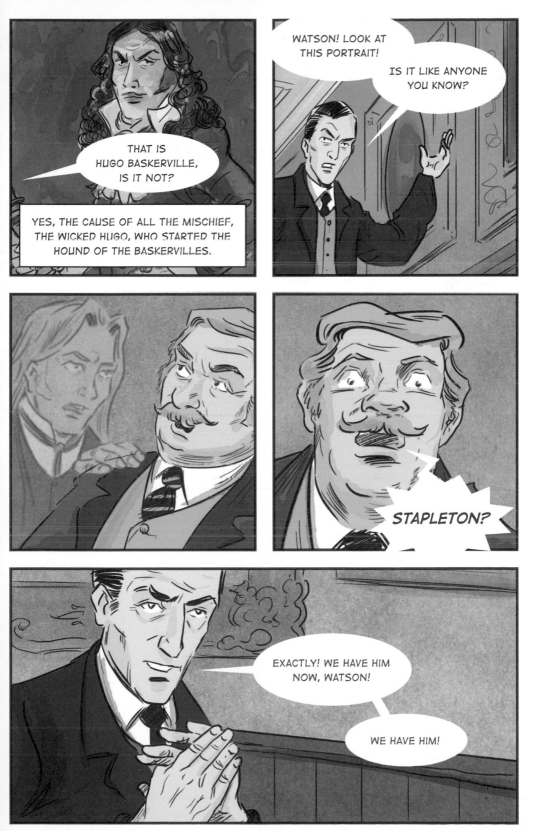

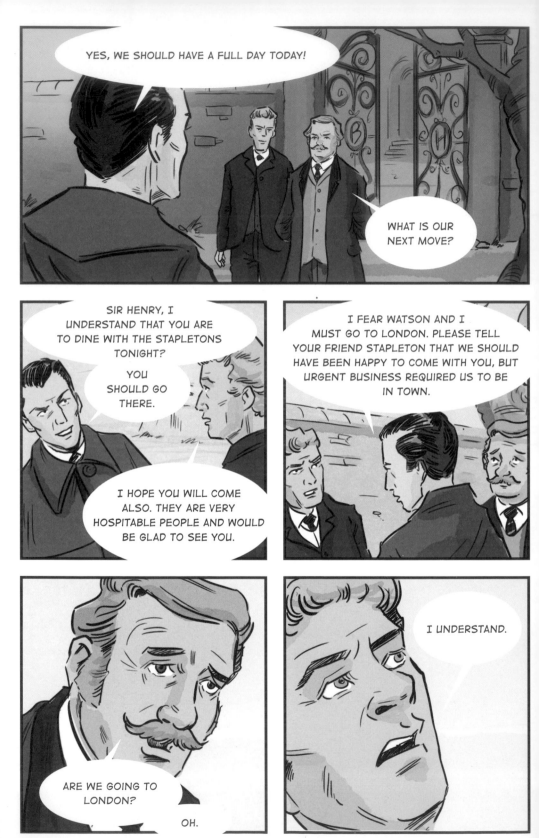

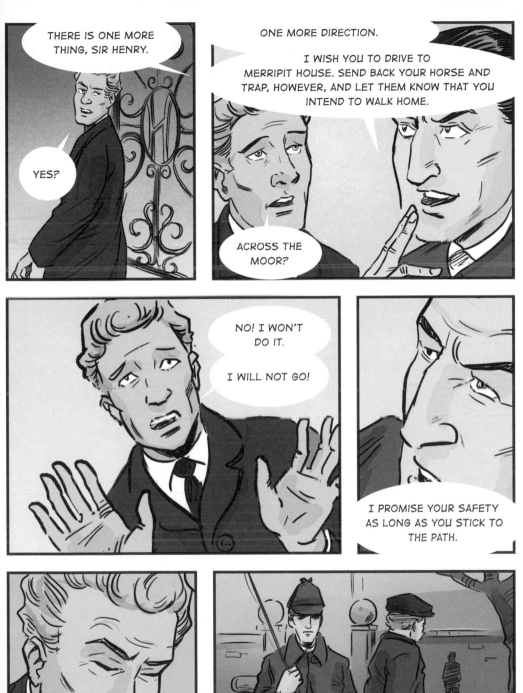

THERE IS ONE MORE THING, SIR HENRY.

YES?

ONE MORE DIRECTION.

I WISH YOU TO DRIVE TO MERRIPIT HOUSE. SEND BACK YOUR HORSE AND TRAP, HOWEVER, AND LET THEM KNOW THAT YOU INTEND TO WALK HOME.

ACROSS THE MOOR?

NO! I WON'T DO IT.

I WILL NOT GO!

I PROMISE YOUR SAFETY AS LONG AS YOU STICK TO THE PATH.

I...

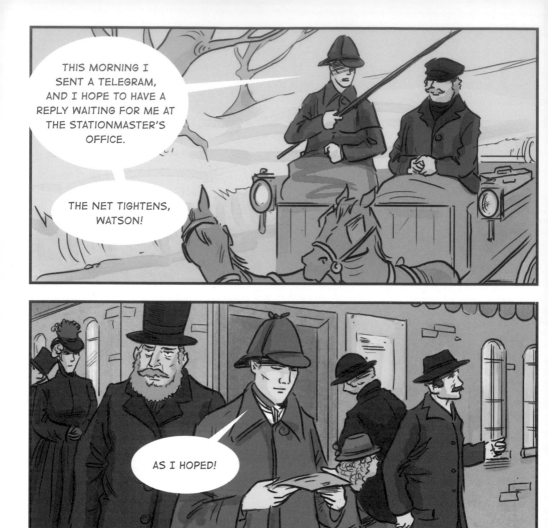

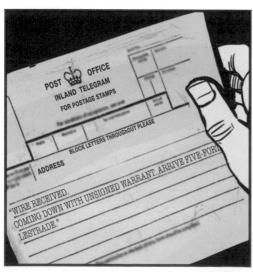

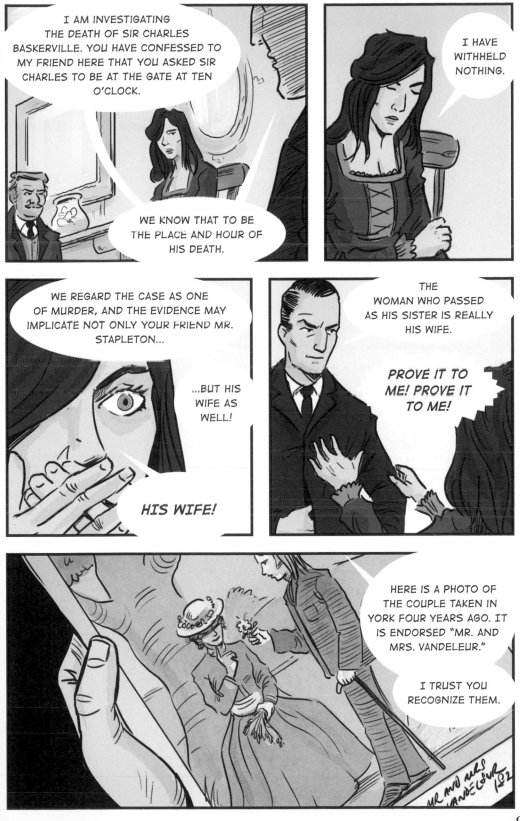

93

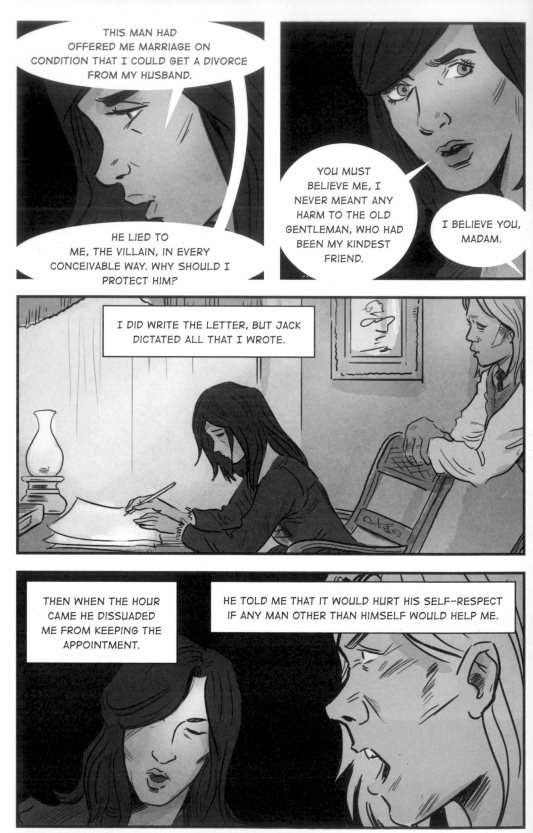

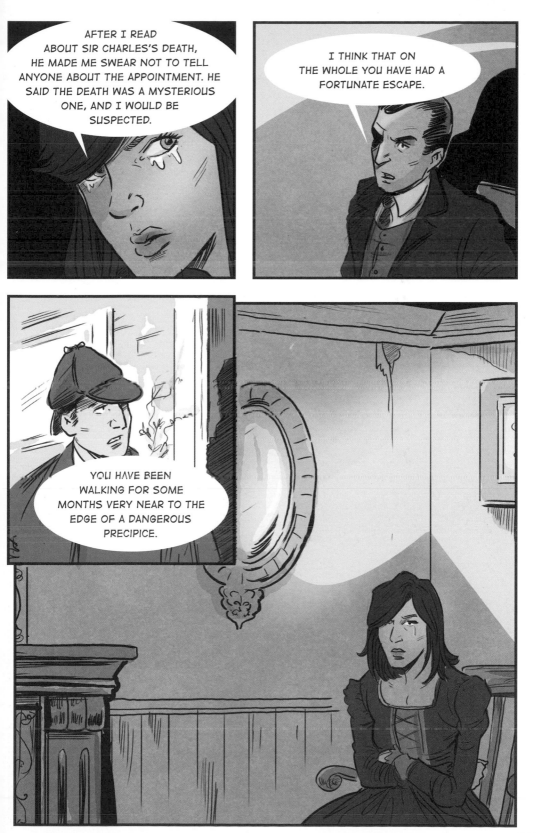

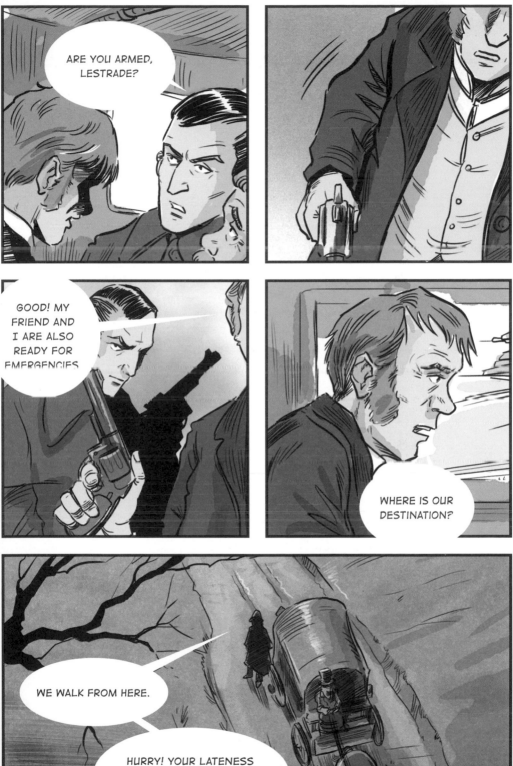

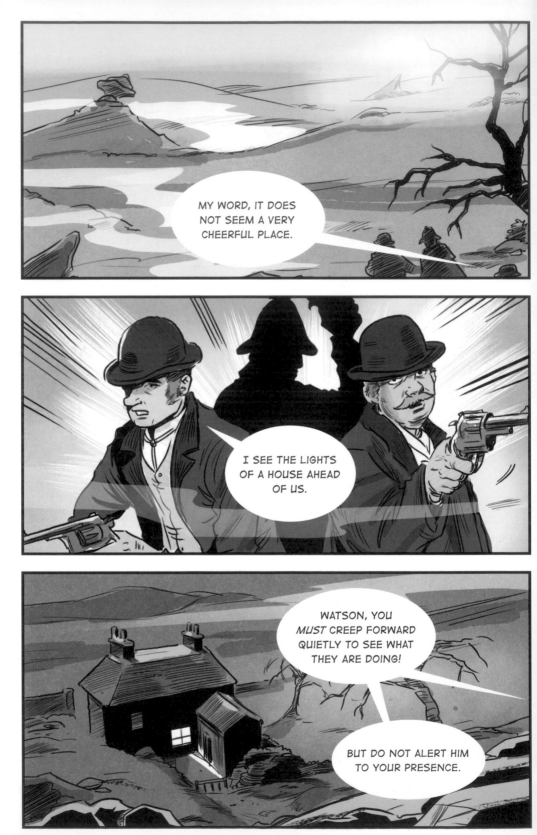

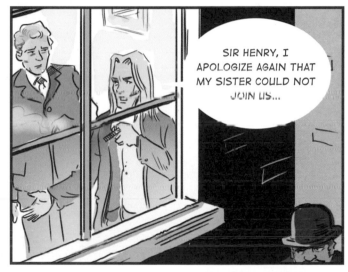

SIR HENRY, I APOLOGIZE AGAIN THAT MY SISTER COULD NOT JOIN US...

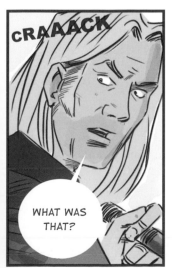

CRAAACK

WHAT WAS THAT?

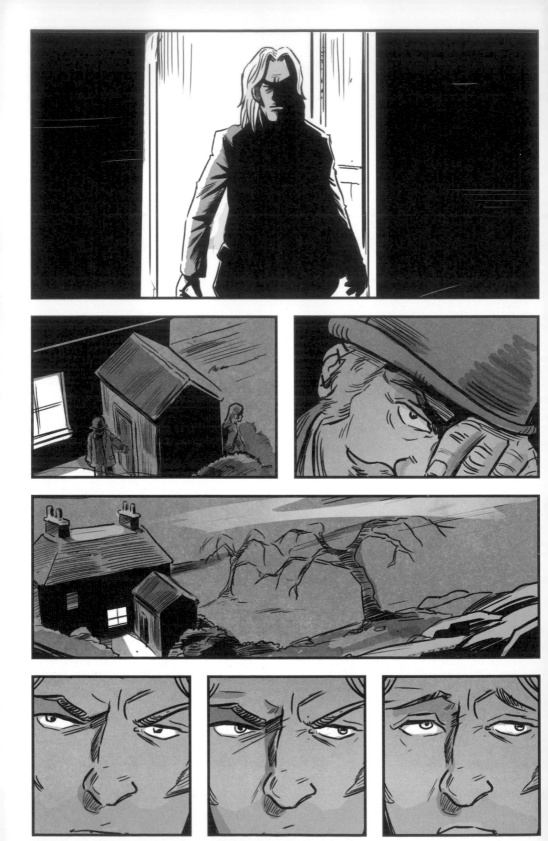

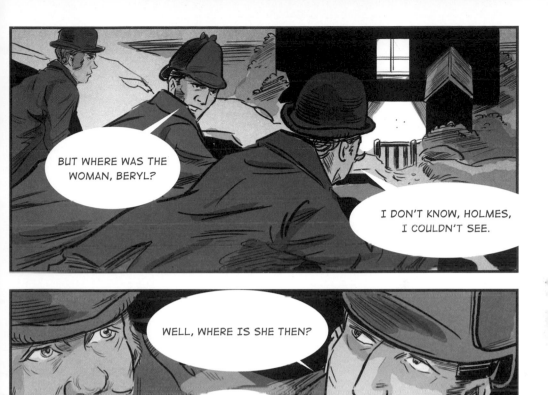

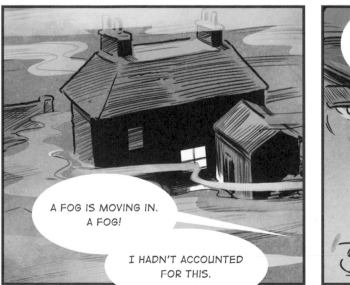

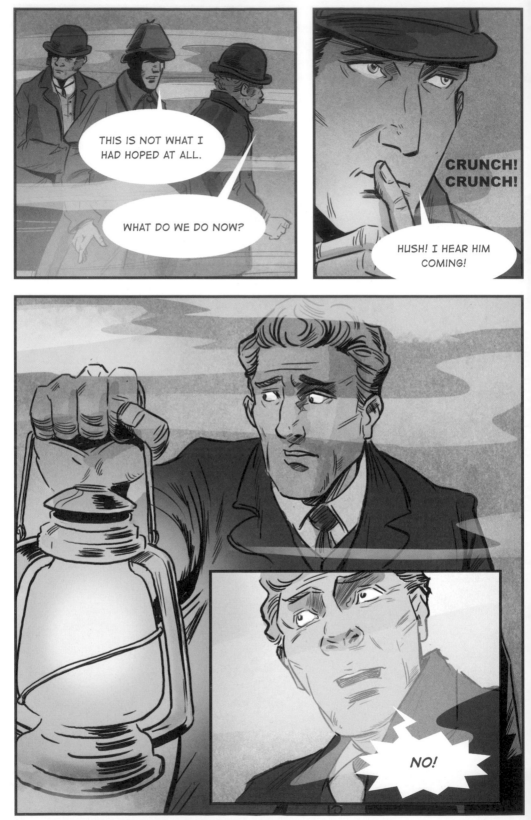

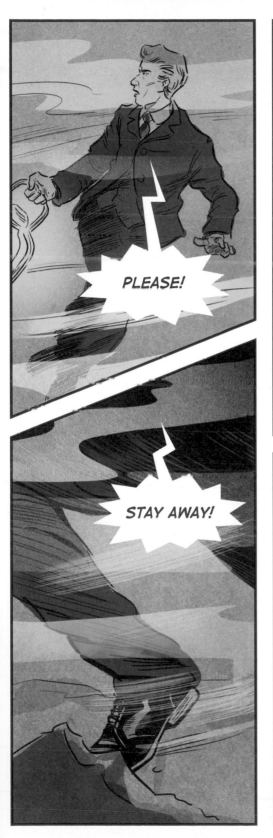

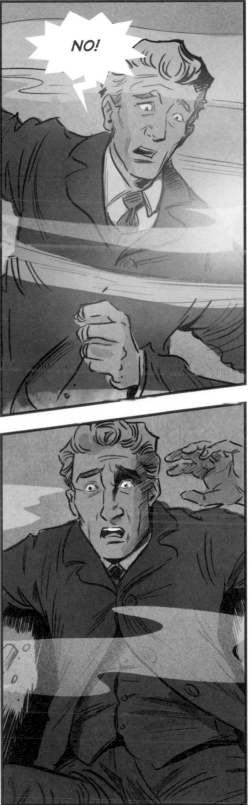

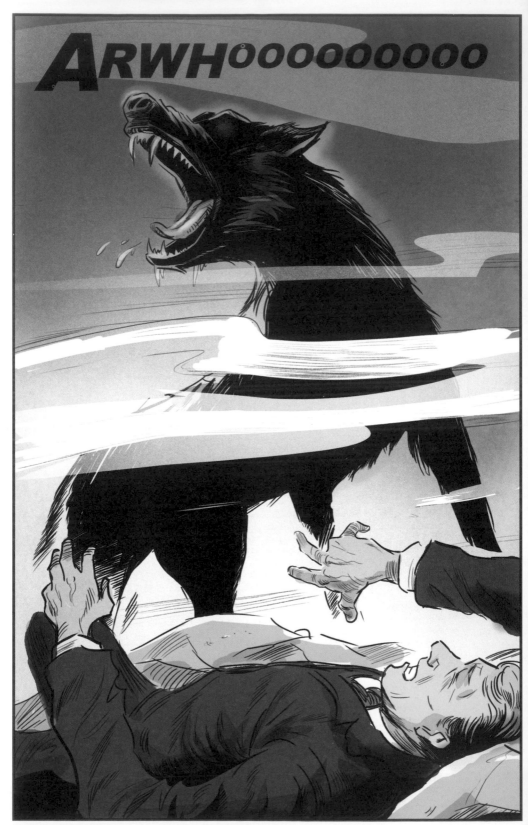

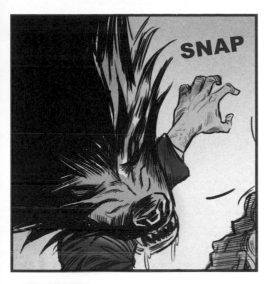

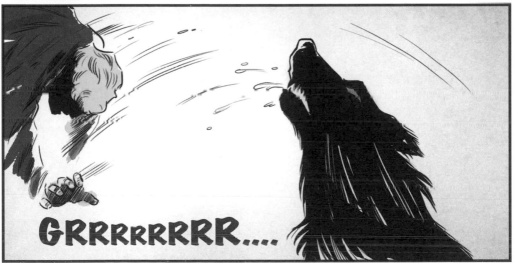

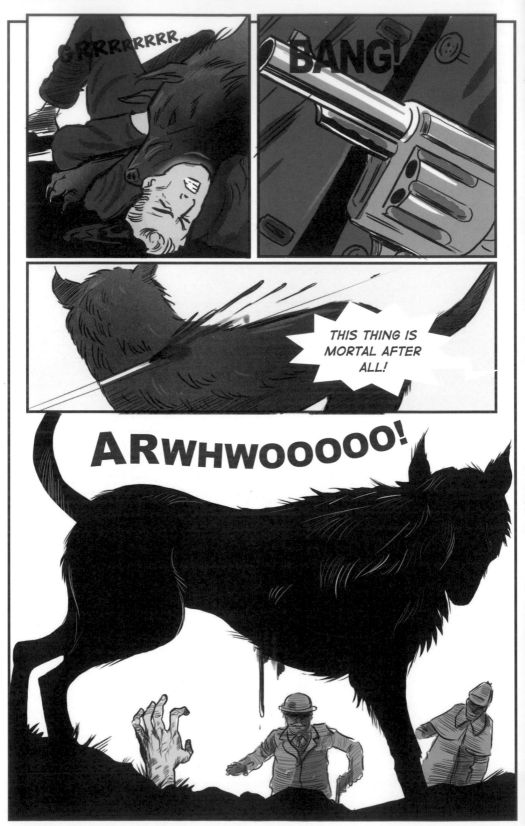

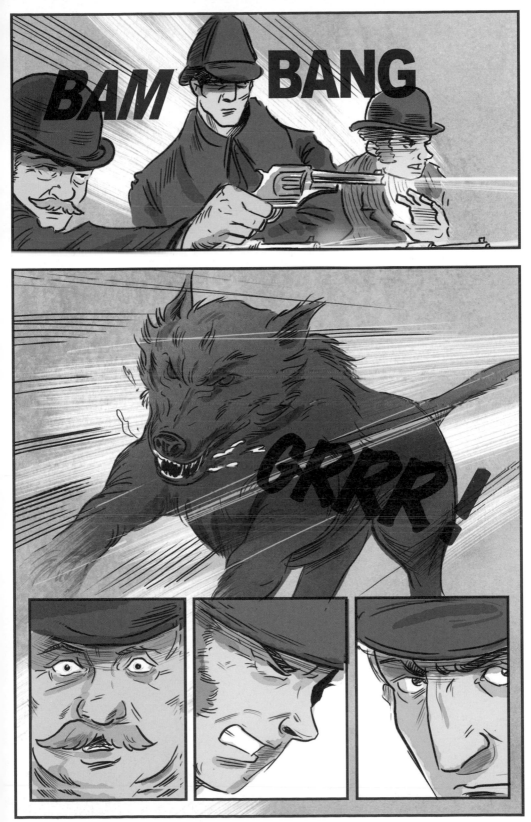

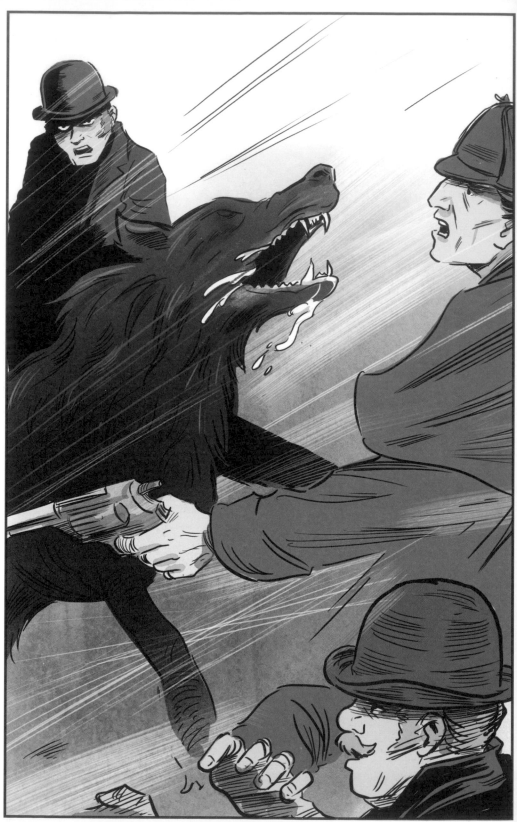

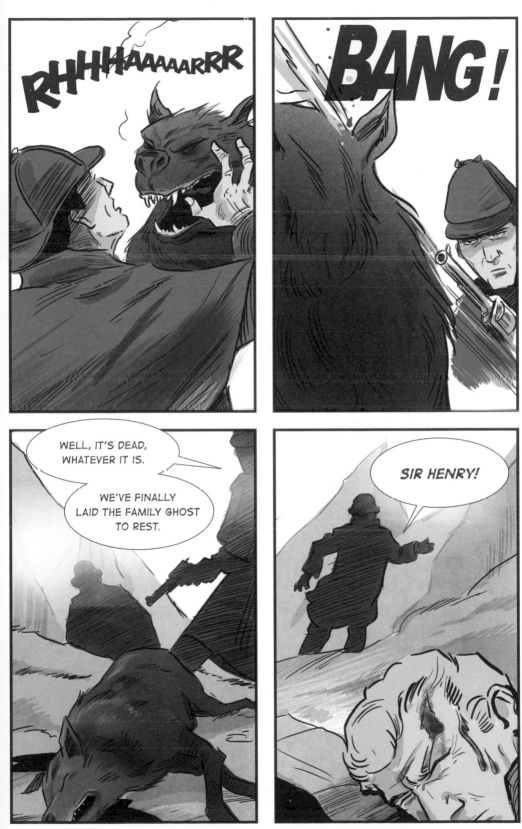

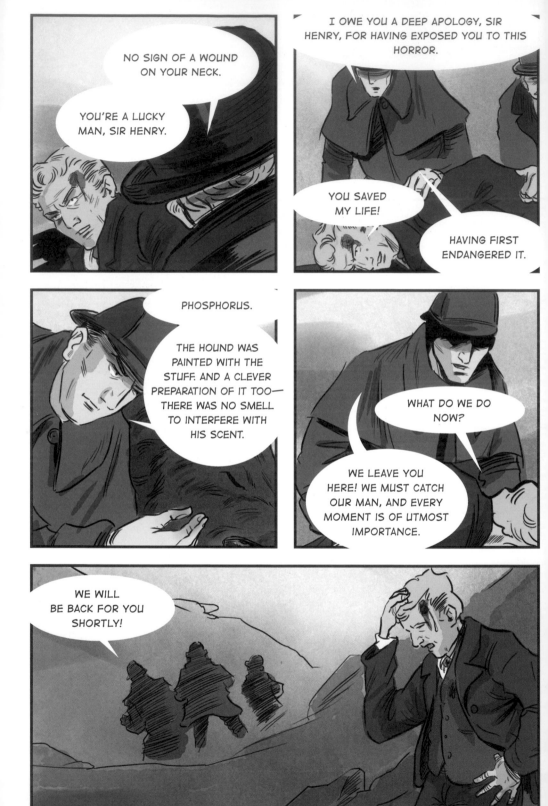

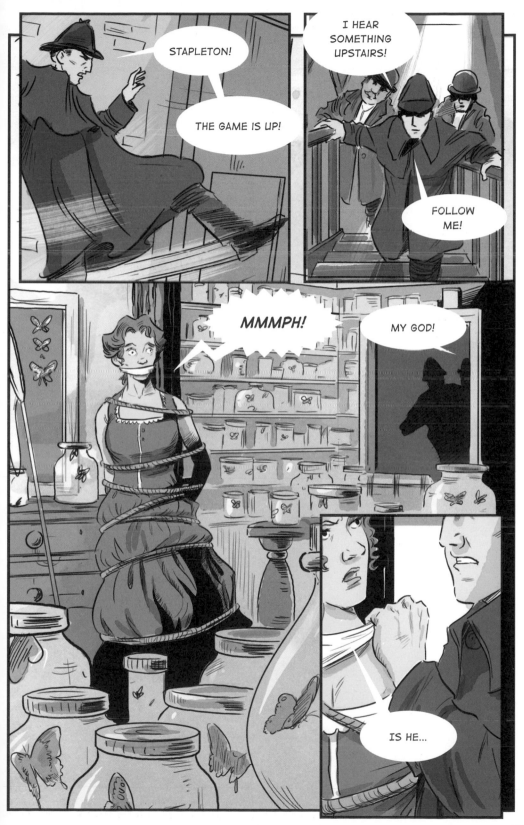

111

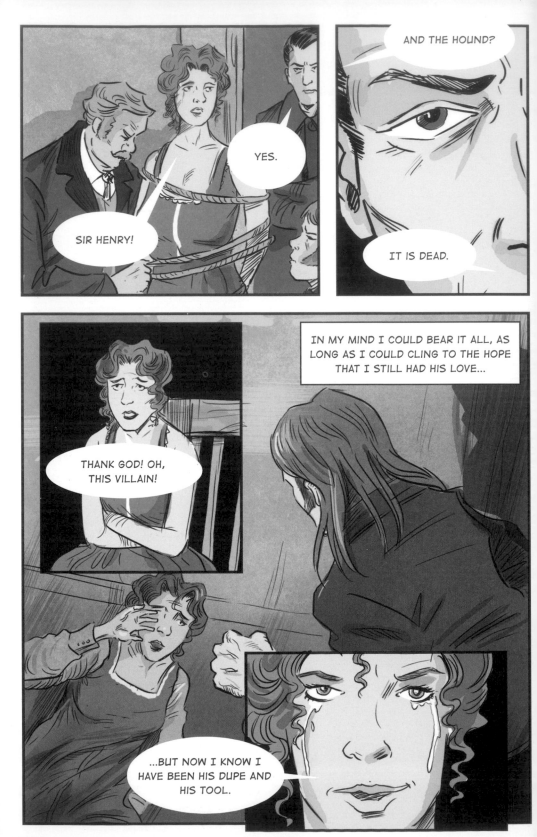

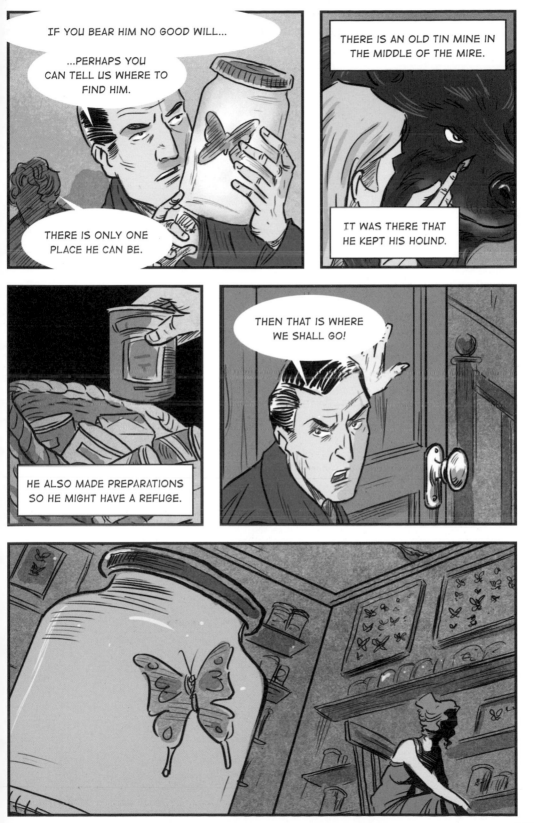

113

BUT ARE YOU SURE ABOUT THIS, HOLMES?

I THINK I HAVE THE FACTS IN ORDER.

MY INQUIRIES SHOW THAT THIS JACK STAPLETON WAS A SON OF RODGER BASKERVILLE...

...THE YOUNGER BROTHER OF SIR CHARLES, WHO WAS THOUGHT TO HAVE DIED UNMARRIED AFTER HE FLED TO SOUTH AMERICA.

IN FACT, RODGER DID MARRY, AND HAD ONE CHILD. THIS FELLOW, JACK.

JACK MARRIED BERYL GARCIA, ONE OF THE BEAUTIES OF COSTA RICA.

AFTER STEALING A CONSIDERABLE SUM OF MONEY IN COSTA RICA, HE FLED TO ENGLAND AND CHANGED HIS NAME TO VANDELEUR.

HE DID INDEED SET UP A SCHOOL, BUT IT FAILED AFTER HIS BUSINESS PARTNER DIED.

THE VANDELEURS CHANGED THEIR NAME TO STAPLETON AND USED THE REST OF THEIR STOLEN MONEY TO MOVE TO THE SOUTH OF ENGLAND.

JACK OBVIOUSLY HAD SOME PLAN IN MIND, AS HE HAD ALREADY STARTED THE SUBTERFUGE OF INTRODUCING BERYL AS HIS SISTER.

HE CULTIVATED A FRIENDSHIP WITH SIR CHARLES, AND FOUND OUT ABOUT THE OLD MAN'S SUPERSTITIOUS FEARS.

STAPLETON KNEW THAT THE OLD MAN'S HEART WAS WEAK, AND SO HE HATCHED AN INGENIOUS PLAN.

THE DOG WAS BOUGHT IN LONDON FROM A DEALER ON THE FULHAM ROAD. IT'S A COMBINATION OF A BLOODHOUND AND A MASTIFF, I BELIEVE.

HE BROUGHT IT DOWN ON A NEARBY TRAIN LINE AND WALKED IT OVER THE MOOR SO IT WAS NOT SEEN BY NEIGHBORS.

THERE ARE PLENTY OF ABANDONED HOUSES NEAR THE OLD TIN MINE. IT WAS EASY WORK FINDING A HOUSE FOR THE DOG WHERE NO ONE WOULD FIND IT.

IT WAS THIS DOG THAT YOU HEARD ACROSS THE MIRE, WATSON.

BUT HERE HE FOUND A SNAG. SIR CHARLES COULD NOT BE LURED OUT OF HIS HOUSE AT NIGHT.

SEVERAL LOCALS MUST HAVE SEEN THE HOUND WHILE STAPLETON WAS WAITING, AND THIS IS HOW THE LEGEND STARTED.

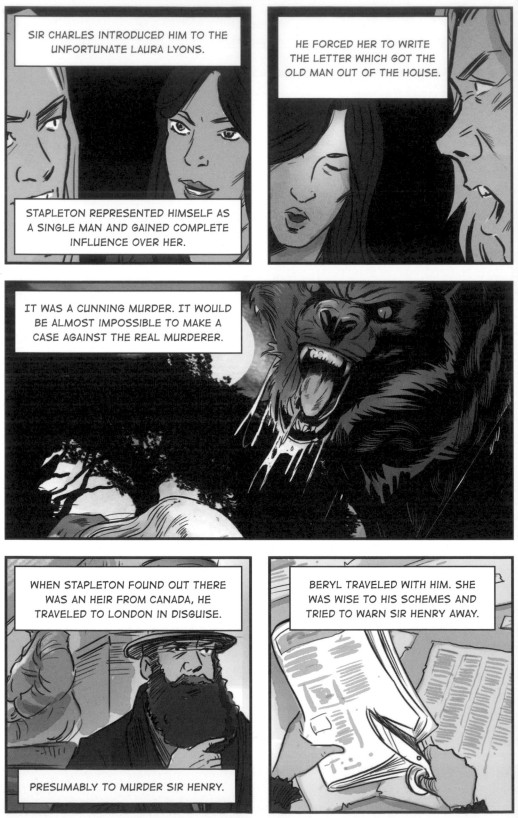

SIR CHARLES INTRODUCED HIM TO THE UNFORTUNATE LAURA LYONS.

STAPLETON REPRESENTED HIMSELF AS A SINGLE MAN AND GAINED COMPLETE INFLUENCE OVER HER.

HE FORCED HER TO WRITE THE LETTER WHICH GOT THE OLD MAN OUT OF THE HOUSE.

IT WAS A CUNNING MURDER. IT WOULD BE ALMOST IMPOSSIBLE TO MAKE A CASE AGAINST THE REAL MURDERER.

WHEN STAPLETON FOUND OUT THERE WAS AN HEIR FROM CANADA, HE TRAVELED TO LONDON IN DISGUISE.

PRESUMABLY TO MURDER SIR HENRY.

BERYL TRAVELED WITH HIM. SHE WAS WISE TO HIS SCHEMES AND TRIED TO WARN SIR HENRY AWAY.

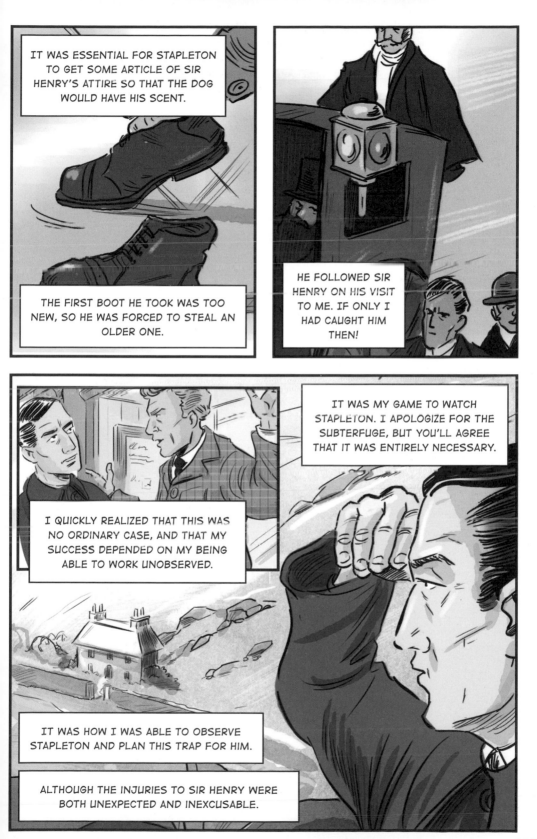

IT WAS ESSENTIAL FOR STAPLETON TO GET SOME ARTICLE OF SIR HENRY'S ATTIRE SO THAT THE DOG WOULD HAVE HIS SCENT.

THE FIRST BOOT HE TOOK WAS TOO NEW, SO HE WAS FORCED TO STEAL AN OLDER ONE.

HE FOLLOWED SIR HENRY ON HIS VISIT TO ME. IF ONLY I HAD CAUGHT HIM THEN!

IT WAS MY GAME TO WATCH STAPLETON. I APOLOGIZE FOR THE SUBTERFUGE, BUT YOU'LL AGREE THAT IT WAS ENTIRELY NECESSARY.

I QUICKLY REALIZED THAT THIS WAS NO ORDINARY CASE, AND THAT MY SUCCESS DEPENDED ON MY BEING ABLE TO WORK UNOBSERVED.

IT WAS HOW I WAS ABLE TO OBSERVE STAPLETON AND PLAN THIS TRAP FOR HIM.

ALTHOUGH THE INJURIES TO SIR HENRY WERE BOTH UNEXPECTED AND INEXCUSABLE.

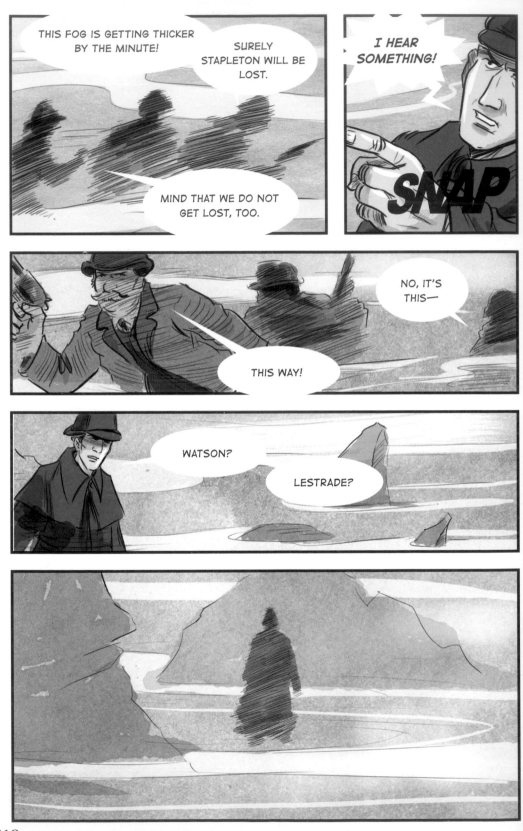

118

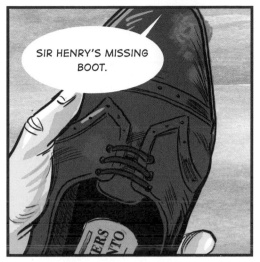

SIR HENRY'S MISSING BOOT.

I WONDER...

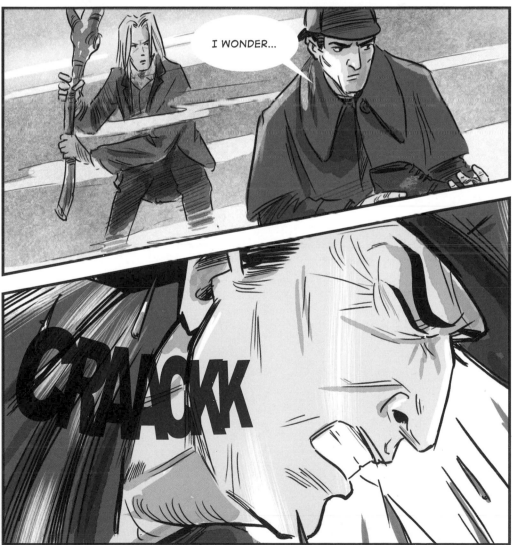

CRAAOKK

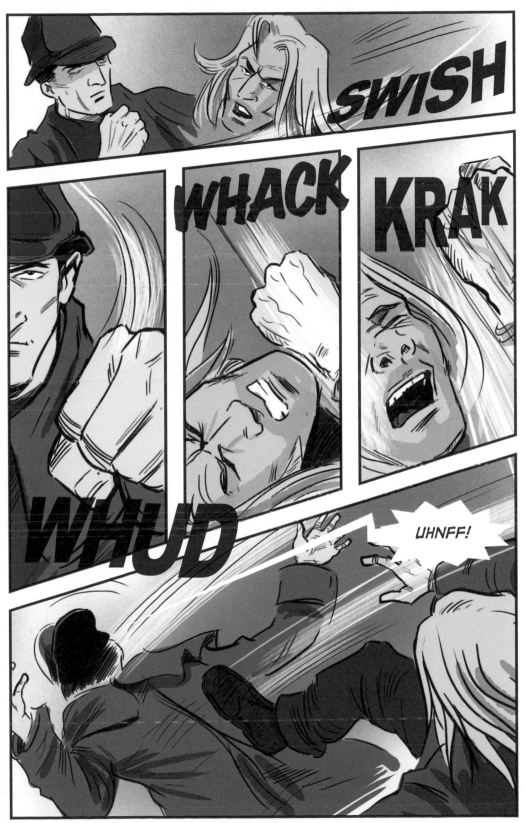

121

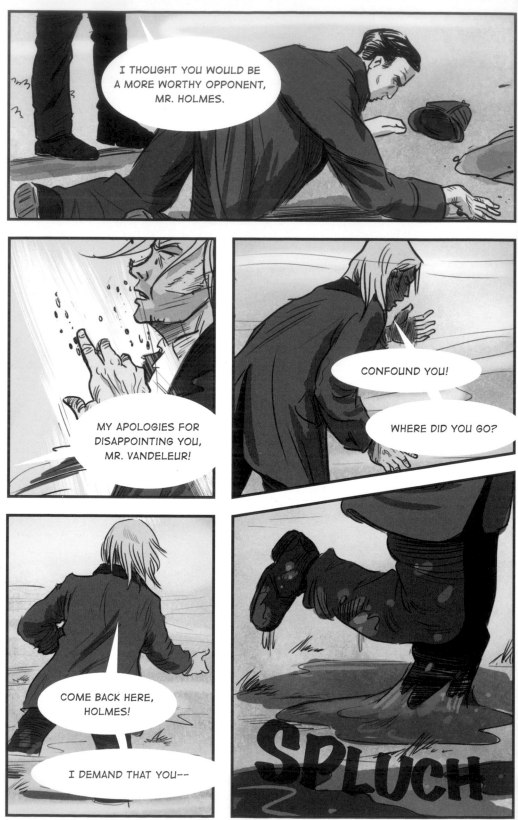

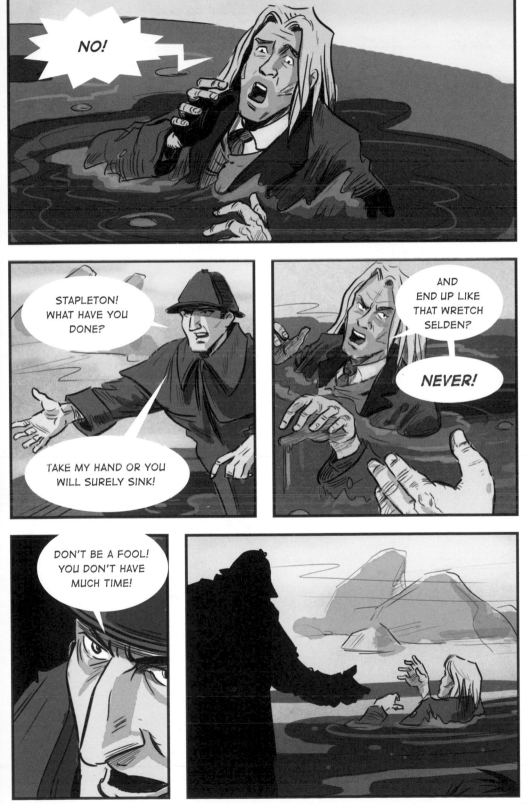

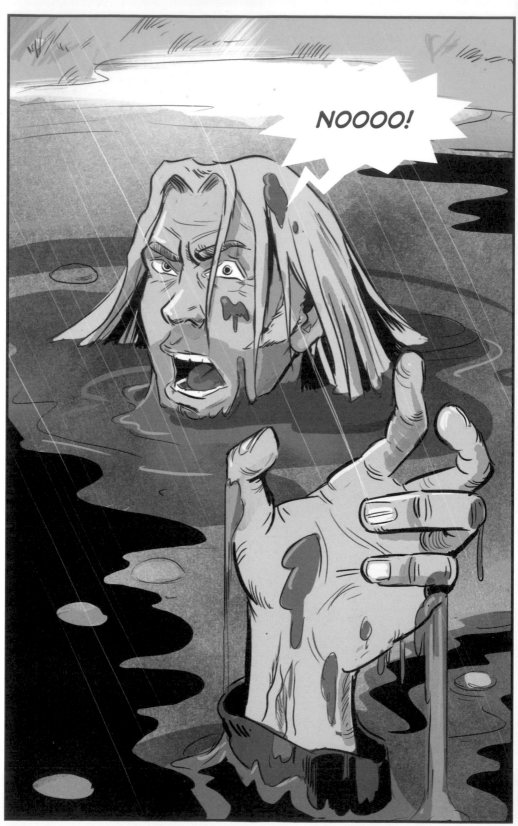